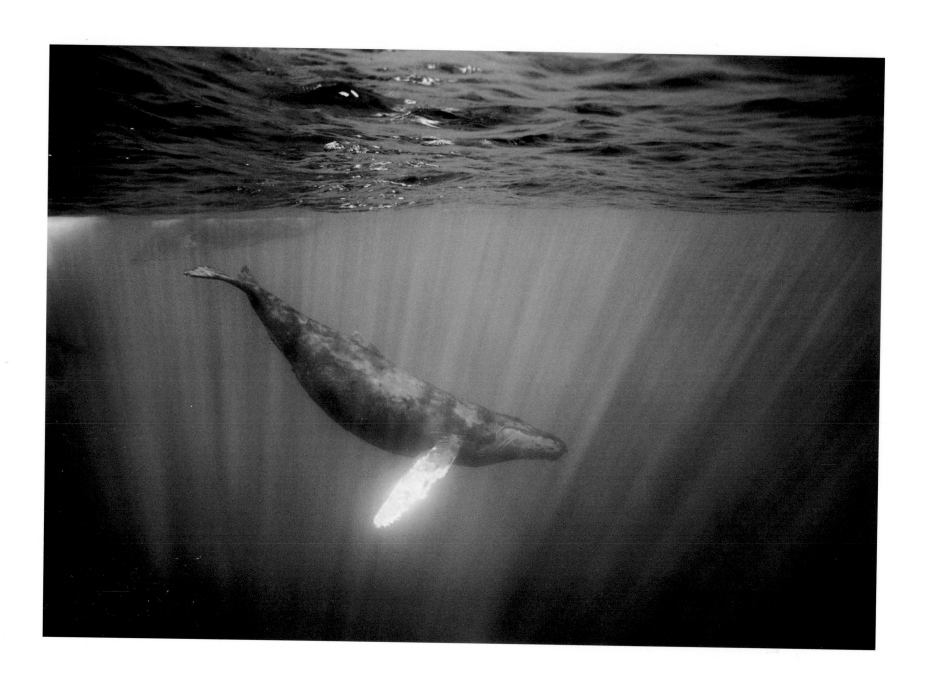

Photographs by Wayne Levin

Through A Liquid Mirror

Introduction by Thomas Farber

An Editions Limited Book

ISBN 0-915013-18-5 Hardcover
ISBN 0-915013-19-3 Softcover

Published by Editions Limited
P.O. Box 10150
Honolulu, Hawai'i 96816

Typography and production by
Barbara Pope Book Design
Printed in Singapore by
Toppan Printing Company

First Edition 1997

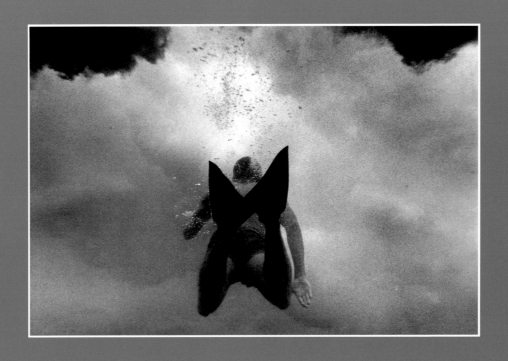

For David Brian Levin, 1979–1991

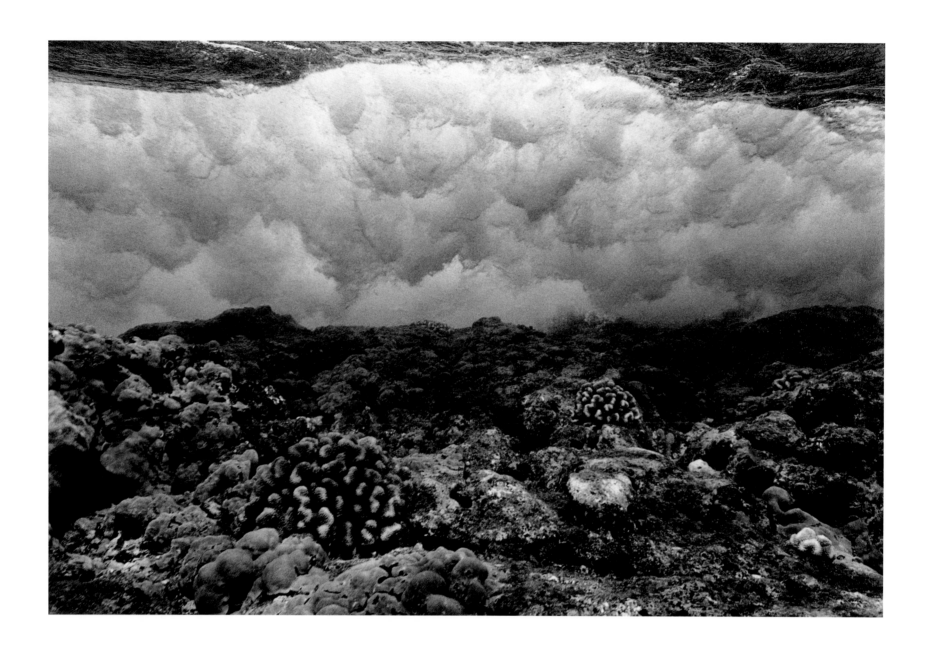

For the Greeks, the sea was a kind of Beyond. . . .
To return from these waters, one needed the assent of the gods.
—— Marcel Detienne ——
« *The Masters of Truth in Ancient Greece* »

Contents

All photographs in this book were taken in waters
off the islands of Hawai'i, O'ahu, and Kaho'olawe
(Hawaiian Islands); Cocos Island (Costa Rica);
Chuuk (Caroline Islands); Bikini Atoll (Marshall Islands).
All photographs in the section Wave Riders were
taken in waters off O'ahu.

Introduction by Thomas Farber

PICTURE this, a speck of land on the water planet. Cocos Island, three hundred miles west of Costa Rica. Steep cliffs, dense vegetation; gorges, ravines, rain forest. Frigate birds, those klepto-parasites (and cannibals), soaring, soaring. Below the ocean's surface, meanwhile, an oasis: around the seamounts and pinnacles, manta rays, cloud clusters of bigeye jacks, strong currents, and . . . sharks. Whitetip reef sharks, gray, slender, about five feet long, dozens of them, common as reef fish, generally motionless (being nocturnal), moving away only reluctantly, grudgingly.

If here, in scuba gear at eighty or one hundred feet, if here the whitetips become profane, the hammerheads do not. Hammerheads, some six to eight feet long, head flattened and extended to both sides, an eye far out on either edge. These "lateral extensions" making a width equal to a quarter of the shark's length. This forward wing increasing lift and maneuverability, or improving sight and smell by spreading the sense organs. The eyes, from the human point of view, enormous, distended. Mouth relatively small, compared to other sharks': jack-o-lantern leer. Hammerheads frequently moving with a kind of strutting wag, as if hinged in the middle, torso and head wrenching one way, the rest of the body the other. Or, startled, they disappear in a millisecond. Making one realize just how suddenly they could *re*appear.

Imagine, suddenly beholding a flotilla of hammerheads, imagine the impact of these silhouettes on the cerebral cortex, message imprinted eons ago. Imagine the depth, mirror of the surface so far above; the cold upwellings; currents that threaten to sweep one away from the (relative) safety of the pinnacle. Imagine, then, moving *toward* the hammerheads. Artist at work.

*

Or, picture this: the Kona (leeward, southern) coast of the Big Island of Hawai'i, land still being born through volcanic eruptions, ocean forever reshaping, reclaiming, that land. Kealakekua Bay opening out to the deep blue, in the wind shadow of the massive, long, high wall of Mauna Loa (fourteen thousand feet above—and twelve thousand feet below—sea level). The extraordinary human karma here: where, for instance, English navigator James Cook met death at the hands of

Native Hawaiians two centuries ago, one of the still-oscillating symbolic moments expressing Past and Other in the Pacific.

The vast lake of this ocean, the also-vast vault of the sky. Tropic sun burning the neck and shoulders, reflection of light blinding, disorienting. Glassy conditions, surface for miles improbably calm, flat, silent. Blue extending to seeming infinity as it curves beyond the horizon. Paddling out, leaving behind the primal soup of the reef, its plethora of colors/shapes/urgencies. Here, in mask and fins, down into *aqua incognita,* a filled but empty space (except for countless tiny plankton, just-visible transparent microplanets). In this "tedious waste," as Charles Darwin called it, one's increasingly disoriented given the absence of referents, enormous broad shafts of light spiraling . . . *up* from below.

Through the quicksilver interface for air, and . . . dorsal fins slicing the butter of the surface: as if to intentionally confuse things further, the circling wheel of spinner dolphins surfacing, submersing. Of course individual virtuosos catapult through the surface, but it's as part of a group they arrive—say, one/five/four/two, front to back. Even as the eye sees this, however, the formation alters depth and angle, if without visible movement, image lost just as it's being perceived. Talk about spin control! Another image offered at a different distance, or perhaps now the squadron's also changed to one lead dolphin, pod behind. At which point, *surprise!,* a group's within touching distance, dolphins' right eyes staring, one's own eye now staring back. At the cookie cutter shark bites, for instance, which seem enormous even as one mutters, cautioning against hyperbole, *water magnifies.* Further complicating the eye-mind dialogue. The dolphins then both suddenly, but without apparent use of force, heading away. And, flukes now moving, spiraling down into what is both transparent and invisible. *Gone.* From the very moment of contact having threatened to move beyond one's capacity to apprehend, having induced exultation, yes, but also almost-despair caused by the unrelenting effort to fix a sense of them on the retina.

Imagine, then, between trips back to the surface for more air (the dolphins' trips; one's own), and their chatter, the clicking of their echolocating, all the aural appraisal and disinformation. . . . Imagine, after days of paddling, waiting in a kind of dazed floating suspension blasted by light and space. . . . After such shimmering isolation and stillness, imagine if you can the (almost)

corollary intensity of a human desire to take, to make—to somehow hang onto—an enduring vision of these miraculous creatures.

<center>*</center>

When we see the vast blue, we see not ocean, exactly, but surface: master trickster, chameleon, boundary between water and atmosphere, barrier or seal between two realities. Undulating, dancing, bending, stretching, reflecting on each side the world it faces while obscuring the other. From above, the illusion that reality remains the same as far as the mind can see, that even the other side of the mirror is more of the familiar, if distorted. Still, what's concealed makes itself deeply felt— we know there's more than meets the eye. Evoking, as Wayne Levin's noted, "the obsession of science fiction with another dimension that coexists in the same space as our own or parallel to it, the two divided by an invisible membrane."

Reflection: the casting back of light after hitting a surface. *Refraction:* the change of direction of a ray of light in passing through one medium into another. In the shallows of the ocean, from above one sees objects underwater—light passes through the surface (refraction) and bounces off, say, coral (reflection) and passes back through the surface. The refraction of light, meanwhile, alters how the coral appears from above. Water quickly absorbs ("quenches," Jerry Dennis writes, in *The Bird In the Waterfall*) all but the greens and blues—reds and yellows in the coral are not seen— and ripples or waves on the surface bend the light. More distortion. In addition, the surface reflects what's above it. Usually sky's blue/gray/white, and, near shore, there may be, for example, palm trees. Thus, looking at the surface from above, one sees reflected light superimposed over refracted light, both images moving as the surface moves.

Below the surface the same dynamics obtain, but here the viewer's suspended within the refracting medium. Particularly in shallow water, images on the underside of the surface may be richer than above—often, there are more objects to reflect. Now coral's seen on the ceiling of the undersurface as a reflection. The light's still bent by the rippled surface, creating distortion. There's less overlaying, but as the angle from the viewer to the surface becomes more oblique, there's a point at which the brighter refracted light from above begins to dominate, obliterating the reflection.

Underwater, one's also in a denser medium. Not only does water absorb more light than does air, but minute floating particles further diffuse the light. (In shallow water, light's visible as it streaks through the refracting medium, reflecting off these particles as it does through smoke or fog.) All of which means less visibility; and contrast—the range from highlight to shadow—is reduced, more so with depth.

Because water filters out so many colors, and because with black-and-white film one can use available (rather than artificial) light, getting detail and contrast for areas and ranges not usually workable with color film, the photographer exploring at and below the liquid mirror might be tempted to try it. But black-and-white also eliminates some of the contextual clues inherent in colors, increasing ambiguity or, even, metaphoric possibilities. If the artist's intention is not exactly to reveal the world beneath the surface, but, rather, to deepen the mystery, then you get an idea of what the options of technique begin to imply.

*

A vocation: a calling. Where one's led, the path one chooses. Take a childhood with time spent on the water. Racing sailboats off the California coast, on a given day the ocean quite still, jib or main sheet between two fingers, awaiting the lightest puff of wind; or seeing an escort of leopard sharks off Catalina Island; or, in harbor, mesmerized by reflections of the yachts' no-longer-straight lines of rigging and masts. Add to this your family moving to Hawai'i as you come of age: a deepening of the water connection. Later, factor in crewing on a sailing vessel in the South Pacific: running before a storm at sea with bare poles; or floating over the blue-black abyss while repairing the propeller, looking down . . . too far, overcome by vertigo.

Meanwhile, if since childhood you've been fascinated by seeing the world through the viewfinder of a camera, the way things appear at the edge of the frame, pass across it, then vanish . . . and if as an adult you photograph, say, window displays or dioramas, shooting through the glass, making images that superimpose that larger world the windows reflect onto the "make-believe" world of the display—itself intended to simulate the "real" . . . and if you think of glass as a former liquid and know that water is often "glassy" . . . and/or, if as a young artist you're working at "street

photography," the gist of which is that the photographer, visually inconspicuous in the midst of life, reacts—fast!—to a moment, seeking to catch events rather than objects . . . the photographer then culling those few exposures compelling in composition or in content—which, ideally, transcend what the photographer knew or intended. . . . Given all this, there may come a moment when, long since in love with surf, you purchase an underwater camera and head out with mask and fins into the turbulence and tumult of breaking waves.

<center>*</center>

Working conditions. For these surf photographs, fins, goggles, and a camera strapped to the wrist, down five to thirty feet, in the path of a collapsing wave, reef perilously close. As a large outside wave forms, visibility of perhaps fifty feet suddenly disappears; in seconds what seems like an enormous cumulus cloud approaches, an engulfing dense fog. Diving down, one feels the strong pull of the wave passing over, and then, as it breaks, spray blown off the crest or lip comes down like an instant of heavy rain. The key to survival in rough water being tranquillity further down. Of course, this creates a problem, since you must return to the surface. For air, that is to say.

"I'm slightly toward shore from the surfers," the photographer explains. "The waves are steep; the reef's about four feet below. A board shoots down the face, right at me. I take one exposure, then dive for safety, but the wave's drawn out much of the water. Clinging to the coral, I feel the wake from the fin as it passes inches from my head. Wheeling around, I hit the shutter as the surfer skims across the face of the wave."

Truly, reflex photography: "I have to trust my responses. Not only do the surfers move through visible space in a matter of seconds, but that space itself is in flux. Things happen so fast; my senses lag behind the event. I'm unable to previsualize, but as I react, something triggers my camera before my mind knows what I'm photographing. *Then* my mind pictures what I think I photographed. Usually, however, my mind is wrong."

<center>*</center>

The ocean, that great and incessant collector, leading one on? And/or the implications for any artist of what's been begun, what compels. This sequence of flying surfers over time turning darker, sug-

gesting not only mastery/grace/visual surprise but also . . . jeopardy. Then, for the photographer, there's a run of something different. Hanauma Bay on Oʻahu, a natural aquarium, marine sanctuary nearly always jammed with busloads of all-too-real visitors, most of whom are in a quite alien environment when they enter the water, and aware of it. The sheer quantity of fish, on the other hand, being somewhat beyond the real, and, odder still, these fish unafraid of humans, aggressive, snatching food from hands, nipping fingers. A strange intersection of the human and the piscine. Where, thinks the photographer, each universe beholds the other, but . . . understanding what, making what kind of contact?

There's the phrase, "a prepared mind." After a stay in the Midwest as a visiting artist—"I was a fish out of water" (spending many hours along the local river to keep sane)—the photographer returns to Hawaiʻi, moving to the Big Island above Kealakekua Bay. Which as if inevitably leads to spinner dolphins, purchase of a used kayak, and humpback whales. To endless hours of swimming, free diving as the dolphins at long last explode into one's presence. To days of paddling, floating off the Kona coast, everything still, until in one absolutely unexpected instant there's a loud *whooosh* and a humpback's right there on the surface. The photographer, perhaps not surprisingly, responding by rolling out of the kayak with mask, fins, and camera. To eye level, so to speak.

"I was a little reluctant to use weight belts in an apparently bottomless ocean," the photographer observes, though needless to say he does so—to get down quickly, to see marine mammals at their depth or from below. Dolphins move at human speed or faster, he learns, but whales, even breaching, rise in what appears to be slow motion as ten, twenty, thirty, feet and so many, many tons keep levitating according to some cetacean law of hydraulics.

And then, once again: more waiting. Photographer searching the horizon for sign of a whale's blow, scanning the surface for bubbles, swirl, or shadows suggesting movement below. Focusing and refocusing to discern what's no more substantial than a wisp of smoke. If something's visually persistent in the water, the photographer comes to understand, it's usually human. Or dead. And, he learns, "With cetaceans you really have to almost be looking at one to see it. The result is that you start seeing—imagining—things."

To grasp these essentials takes time, then more time. Year after year, swimming with dolphins off Kona; or hitching rides further offshore to find, say, pilot whales; and then being sent on

assignment to Yap, Chuuk Lagoon, Cocos Island, Bikini Atoll, some of the great dive sites. Sharks (reef, tiger, white, hammerhead, Galapagos); rays (manta, eagle, marbled); wrecks of ships (destroyed in war or in atomic testing, the huge scale, technical achievement, and inescapable fate of these man-made leviathans); yet another wheeling vortex of thousands and thousands of jacks. And, once again at home, the ongoing miracle of one's infant daughter/tadpole (re?)discovering the properties of water. Picture that.

<p style="text-align:center">*</p>

There was a story told before Christ of a fisherman . . .
who found an herb to revive fish as they lay gasping on shore.
He ate it himself and was changed into a sea thing, half fish half man.
Charles Olson, «Call Me Ishmael»

We come from the ocean, they tell us. May, some day, return. Live, like cetaceans, between two worlds. Are "merely highly advanced fishes," icthyologist/paleontologist John A. Long argues in *The Rise of Fishes.* Not surprisingly, the artist is affected, transformed, by his time in the medium in which he works. Though moved by reef animals, the dazzling array of the colors and strategies of the miniature, it's the larger marine creatures which come to him to seem the gods or spirits of their realm. Feeling this as he yet again swims, paddles, or submerges in search of them, waits for them in the broiling sun. This fusion of close observation of the physical world, a passionate specificity, and the heart moved to wonder. Each time passing through the liquid mirror, which so conceals what lies below, the artist quite clear he's delivering himself into the power of something greater than the self, that only by its grace can he (hope to) return.

"I owe a lot to the ocean," says the photographer. And yet: carried off the Kohala coast of the Big Island into the dangerous ʻAlenuihāhā Channel, paddling, hard, the eternity of that first half-hour, without any apparent progress toward land. Diving deep at Bikini: risk of 'getting bent' —of 'decompression sickness' (a euphemism). Or, in the currents at Cocos, the threat of being swept from the pinnacle into the blue in the presence of hundreds of sharks. (Currents: all scuba

users know of the drift divers in Palau who missed—only once, but forever—their boat rendezvous.) The photographer sobered enough to give his writer/friend the secret formula for developing his film. Just in case. Still, he says without hesitation, speaking of the ocean, "I have a lot to be grateful for."

<p style="text-align:center">*</p>

There's a tale written by Franz Kafka—"A Hunger Artist," it's called. Until recently, Kafka's fable goes, hunger artists in circuses—caged, to show they had no access to food—were in vogue; huge crowds paid to watch public fasting. But times change; starvation went out of fashion. Though utterly neglected, still this particular artist fasted. At long last an overseer discovered him in his cage. The dying hunger artist, still starving, whispered that though he'd wanted to be admired for his skill, the truth was he'd never found food he liked. If he had, "I should have . . . stuffed myself like you or anyone else."

Photographers and water: both of them into magic, conjurers of reflection, refraction. Surely a bond. Then too, there's the ocean's siren song; it's a twice-told tale that one must heed its call. Think of mermaids, among other seductions; or Odysseus, for years still voyaging, allegedly always in order to return home; or the great Polynesian navigators, perhaps driven into the deep blue to build a new life, or with a passion for exploring, or led on by the irresistible, evanescent but recurring tracks of migrating birds. It may also be true, however, connected to the ocean for whatever nexus of reasons, that long since the photographer has no more choice than any artist possessing—or possessed by—so insatiable a hunger.

<p style="text-align:center">*</p>

In the late 1980s, beginning to write what was to become *On Water* (1994), I spent much of my time out in the ocean reading water, what was right before my eyes, or, on land, reading the art and literature of water. In Honolulu in 1990, I was given a copy of the inaugural issue of *Mānoa: A Pacific Journal of International Writing* by editor Frank Stewart. There I saw a selection of the photographs of Wayne Levin. Saw and was dazzled: I'd found no ocean art so innovatively accurate while also achieving evocative or symbolic truth. Getting the photographer's phone number and posing as a

potential buyer—how could I begin to explain to a stranger how much I had to learn from his work?—I made an appointment to see his portfolio.

Sharing an obsession, perhaps not surprisingly the photographer and I were soon together in or on the water. In Kealakekua Bay, my shoulders and arms crying out for respite, dolphins bursting out of nowhere to sonogram one's heart, one's soul. Or, hundreds of miles offshore Costa Rica, surfacing in the detonations of a driving rain, having witnessed more sharks than any human central nervous system could render coherent. Or, off the desolate lava fields of the South Kona coast of the Big Island, swimming down and down in a kind of driven yearning, unwilling to lose sight of a large ray's effortlessly rippling, rippling, wings.

Over and again, at sea level or at several atmospheres below, over and again I've seen this photographer leave my field of vision—appear, so to speak, in the viewfinder of my eyes at the edge of the frame, pass across it, and vanish. The photographer free diving, wake of bubbles trailing from his fins, at a range of fifty or seventy-five feet merging into the murk. Or, in his kayak, scanning the horizon, paddling away from shore though day's waning, toward the sunset and so beyond the capacity to make him out, until he's no more than a filament or a memory in one's eye. This insatiable artist surely as difficult to apprehend as the almost-mirages he's for so many years so ardently pursued.

wave riders

The wind speaks the message of the sun to the sea,
and the sea transmits it on through waves.
The wave is the messenger, water the medium.

—— *Drew Campion* « *The Book of Waves* » ——

* * *

The rip pulled us toward the lava at the north end of the beach,
and we had to swim hard to stay there.

. .

We ducked the biggest waves that caught
us inside. A quick breath, then down to kick along the
sand toward the blue haze outside, the wave cracking, pressure
from the white water hissing over us, a cold shadow. We
surfaced on the other side, looked at each other and laughed,
surprised again to have made it into the sunlight and air.

—————————— *Tino Ramirez* ——————————

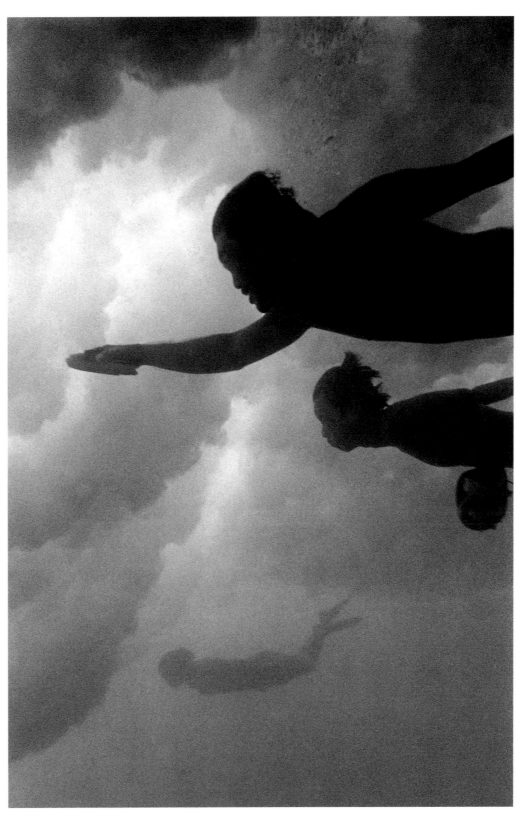

bodysurfers

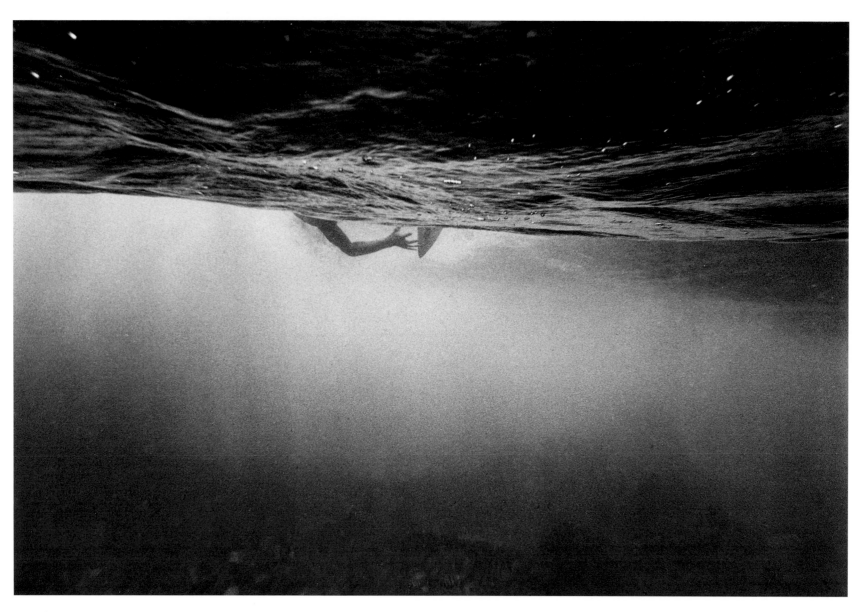

«pearling»

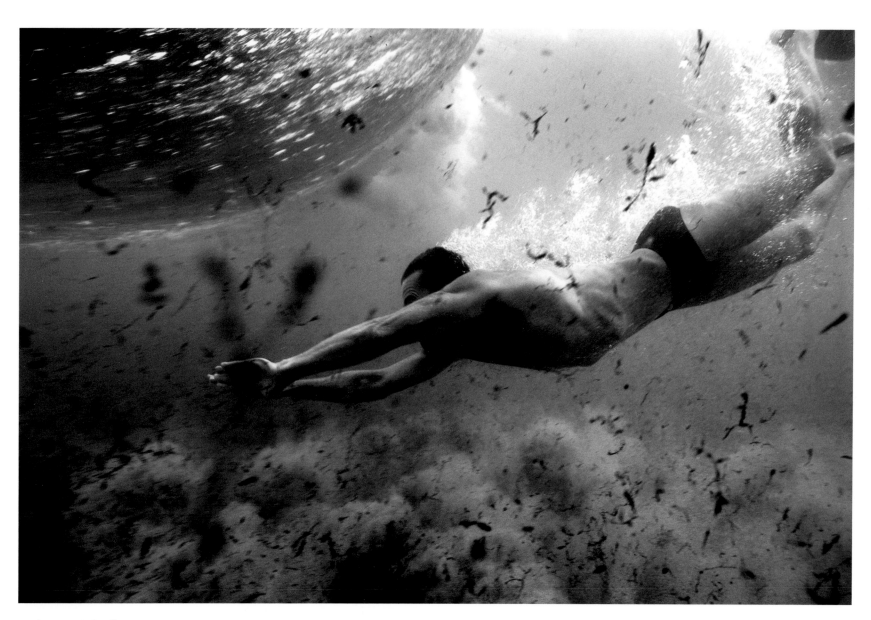

underwater takeoff

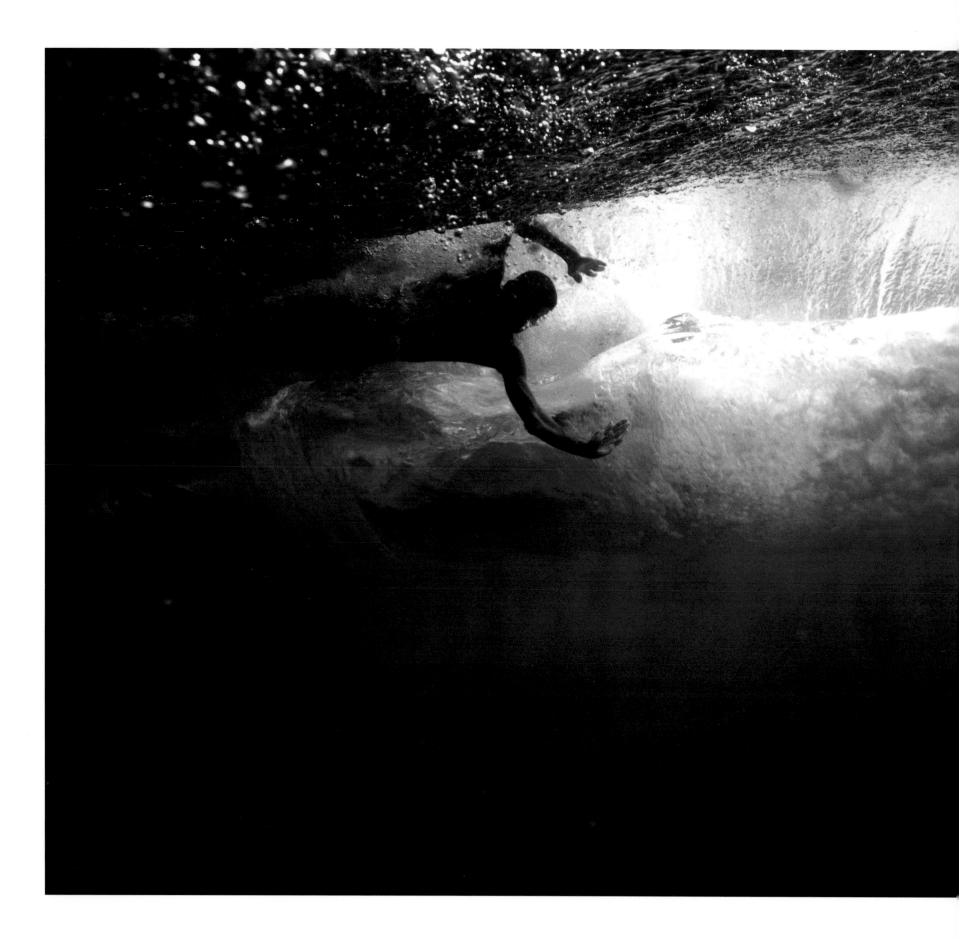

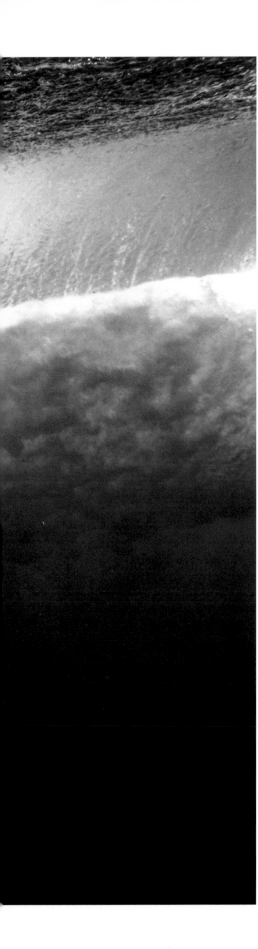

«kicking out»

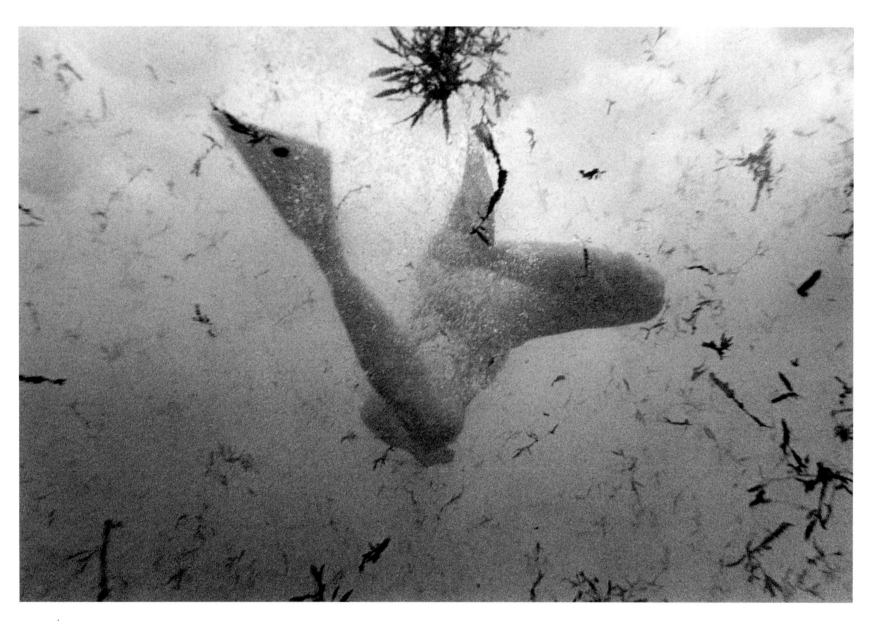

seaweed

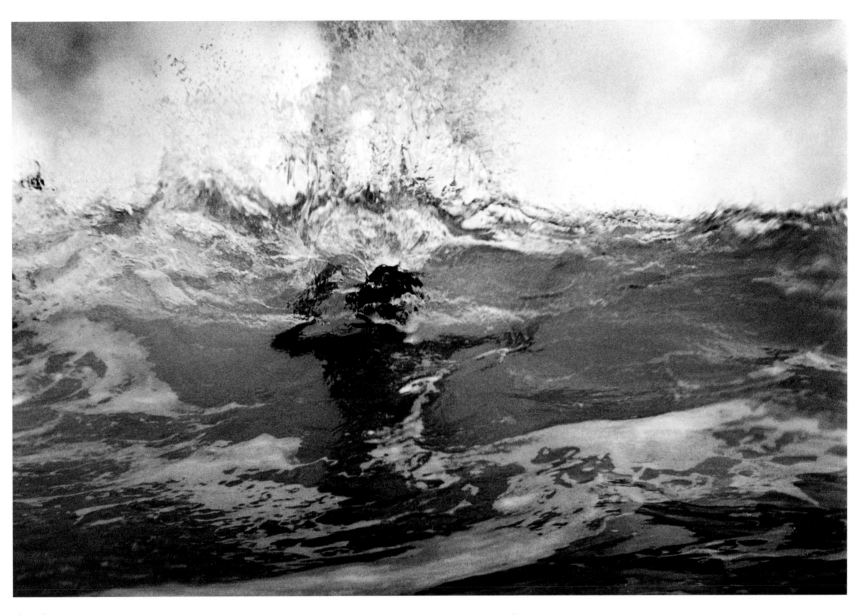

the « lip »

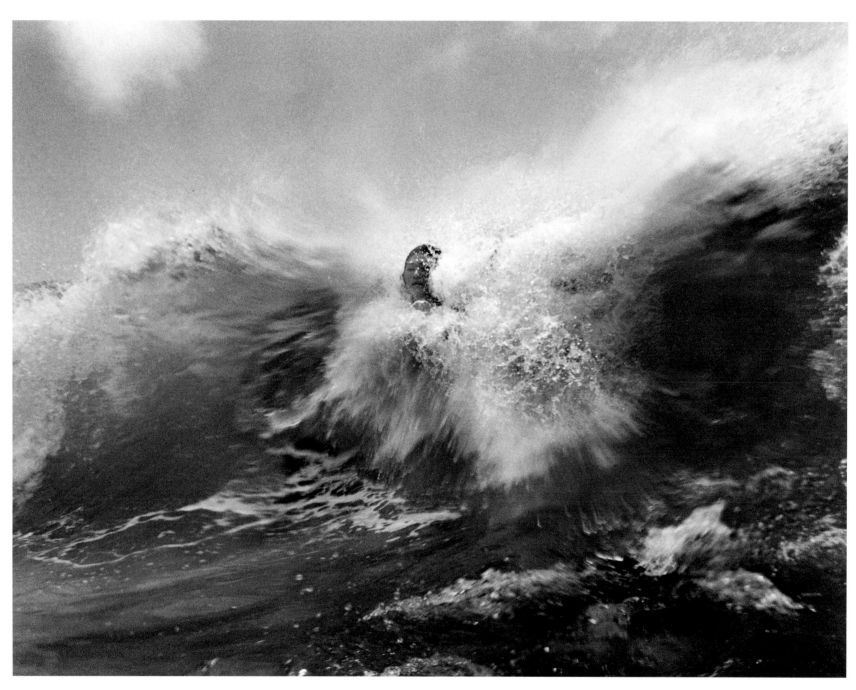

«taking off»

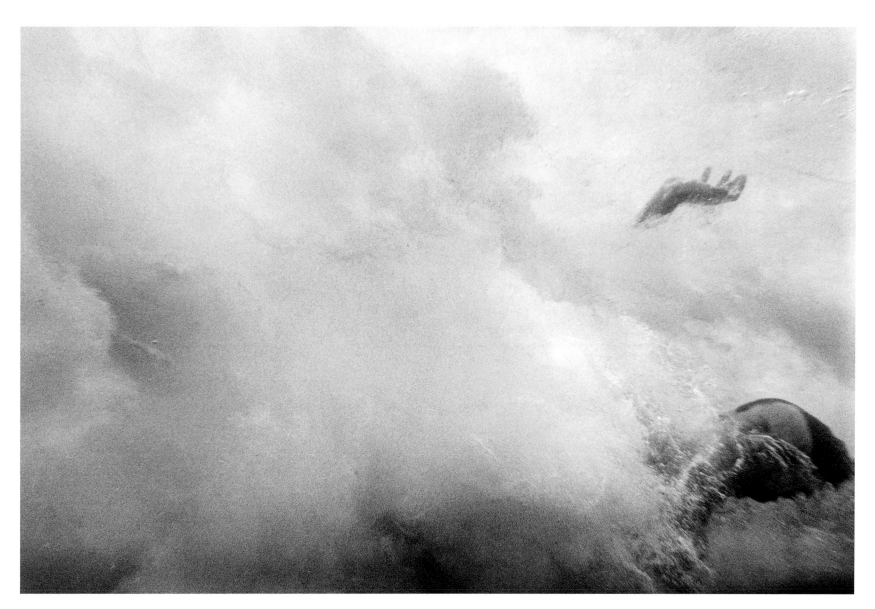

«over the falls»

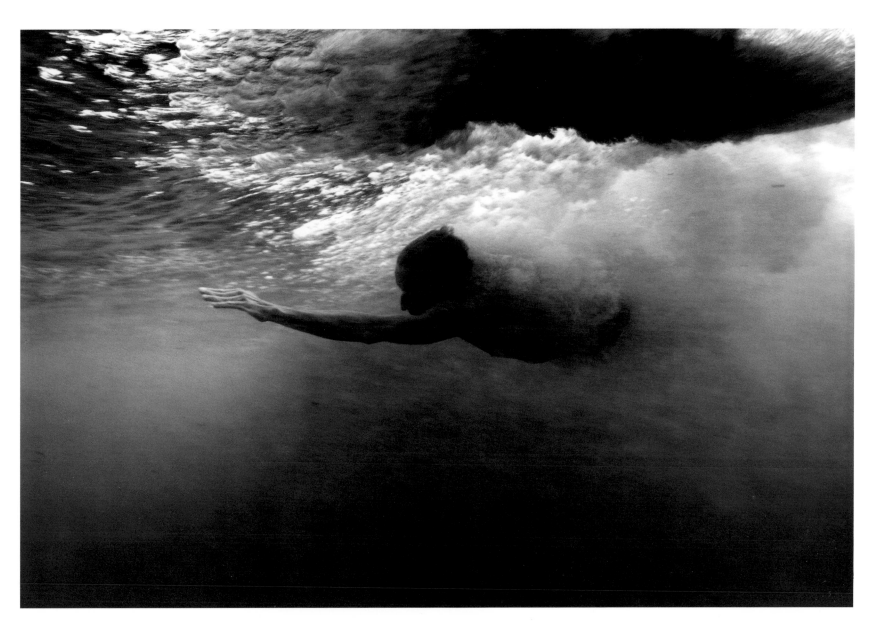

riding underwater

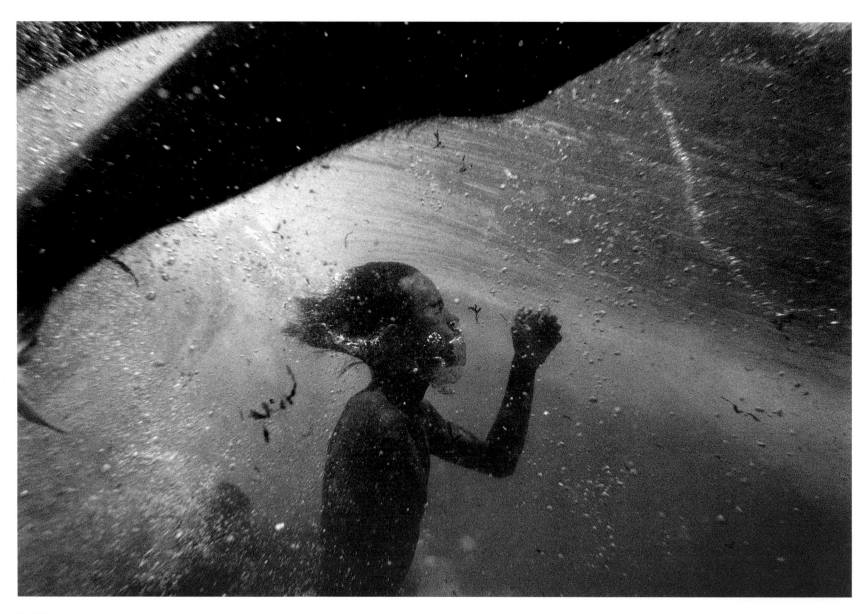

holding breath

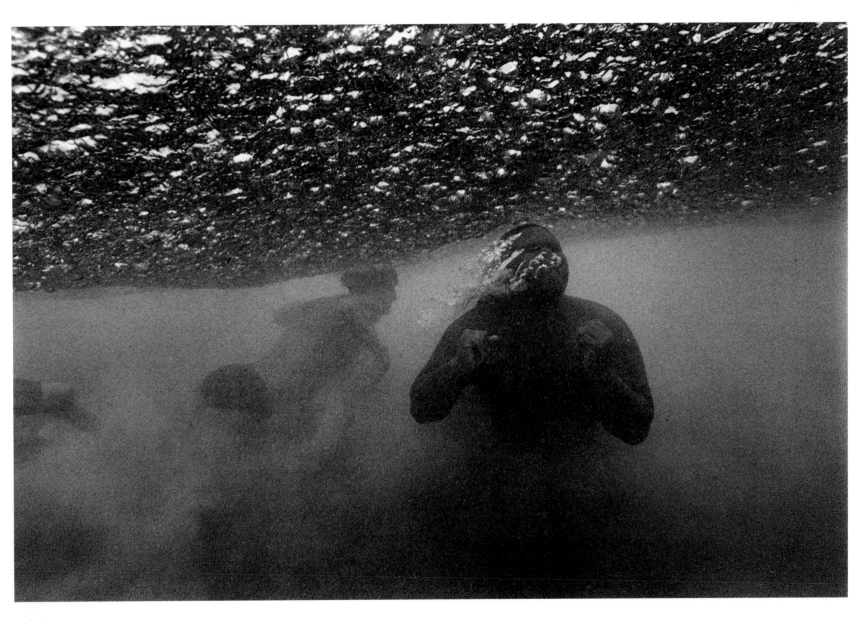

exhaling

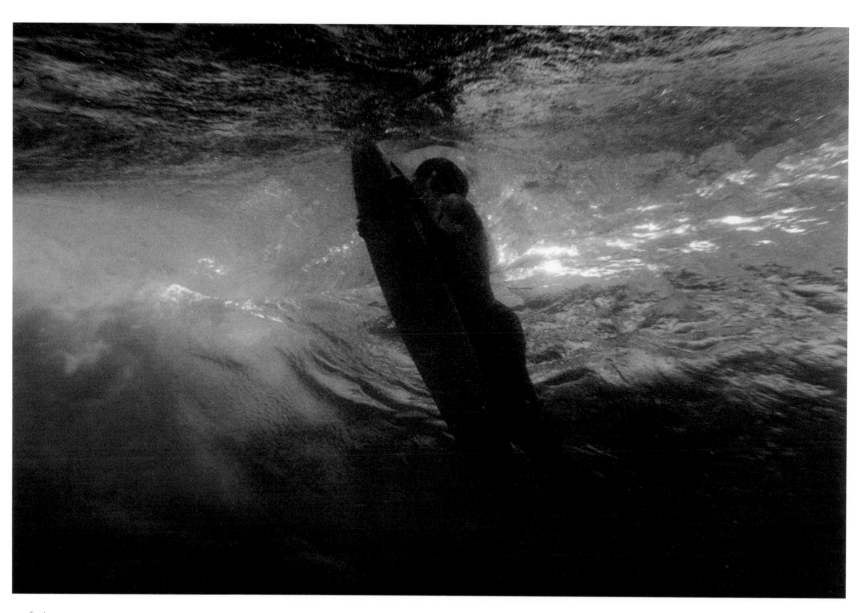

surfacing

spirits inhabit

resident spirits

God quicken'd in the sea, and in the rivers,
So many fishes of so many features,
~~That in the waters we may see all~~

Even that on earth are to be found,
As if the world were in deep waters drown'd.
For seas (as well as skies) have sun, moon, stars.

———————— Du Bartas ————————

quoted in Walton's « The Compleat Angler »

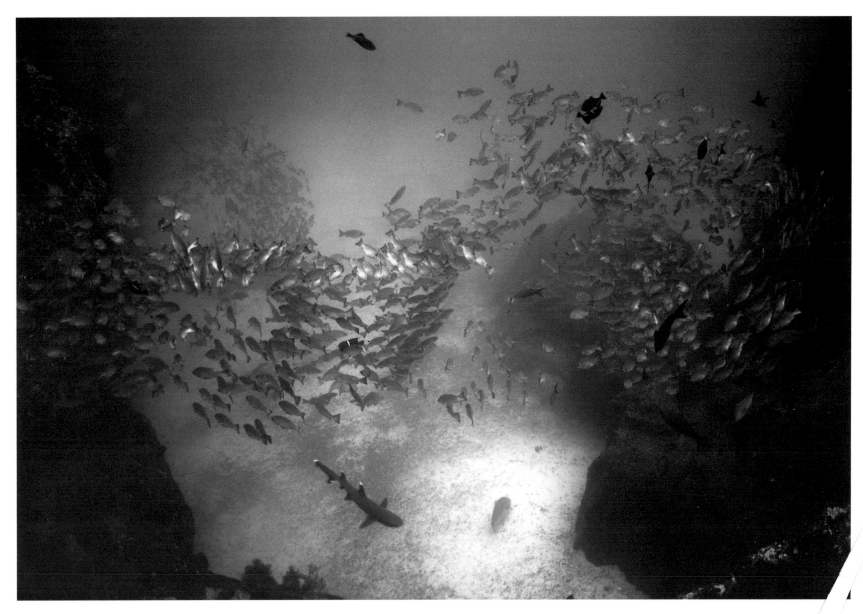

bigeye jacks, whitetip reef shark, and puffer fish, Cocos Island

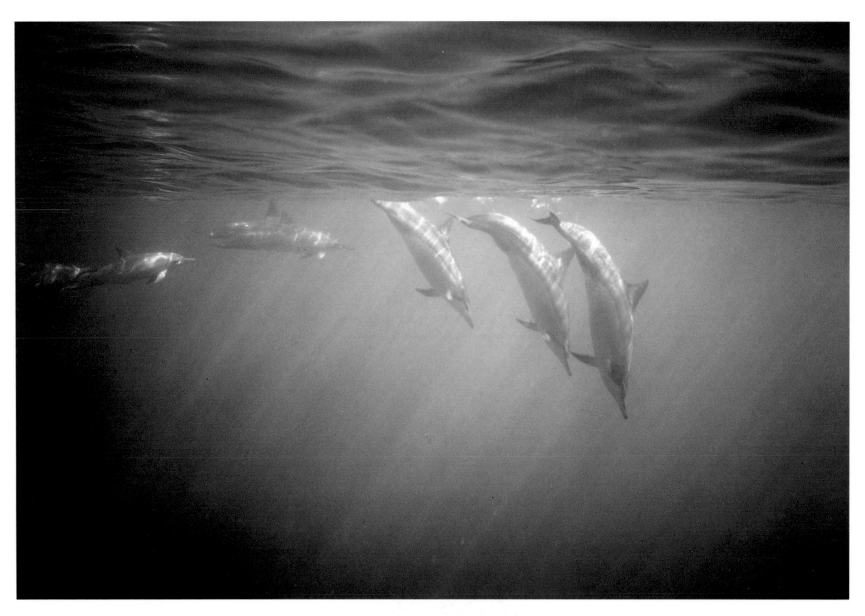

spinner dolphins, Hawai'i

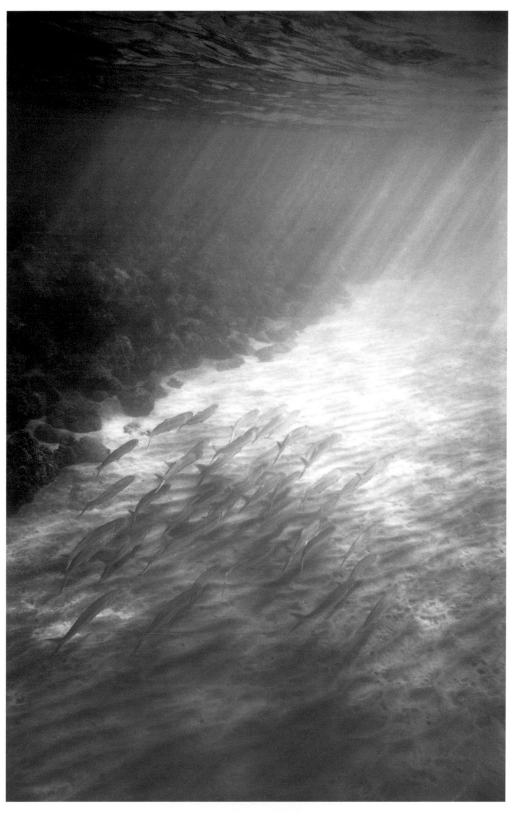

bonefish, Hawai'i

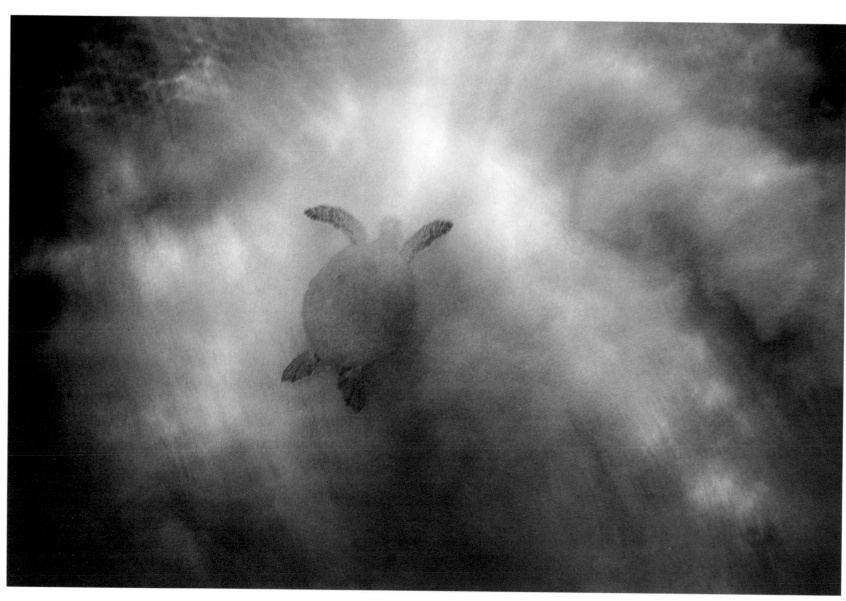

green sea turtle, Hawai'i

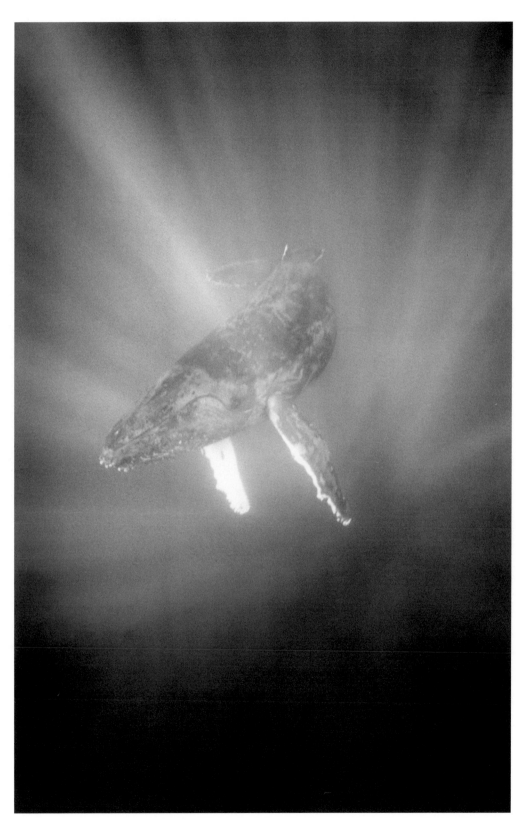

humpback whale, Hawai'i

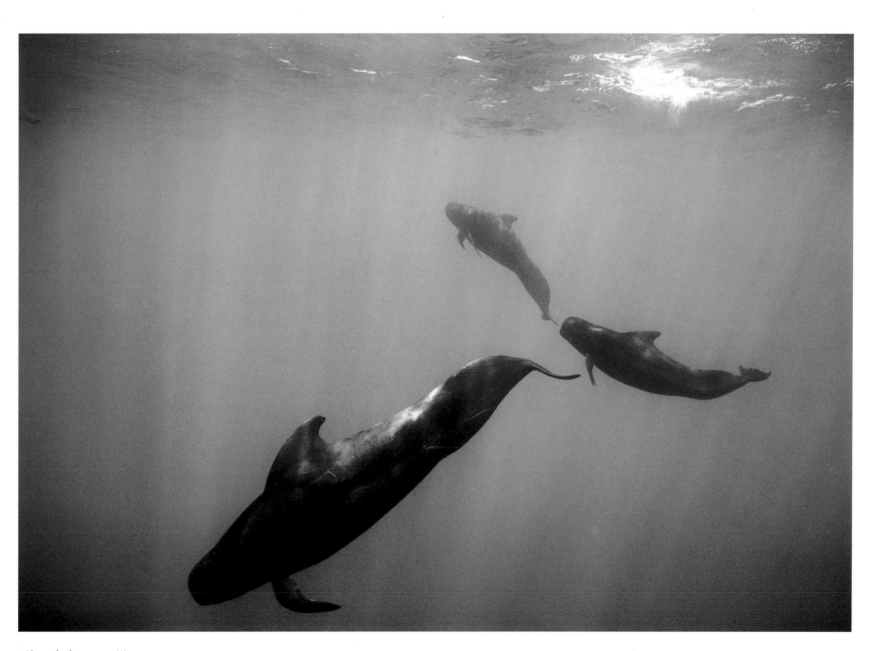

pilot whales, Hawai'i

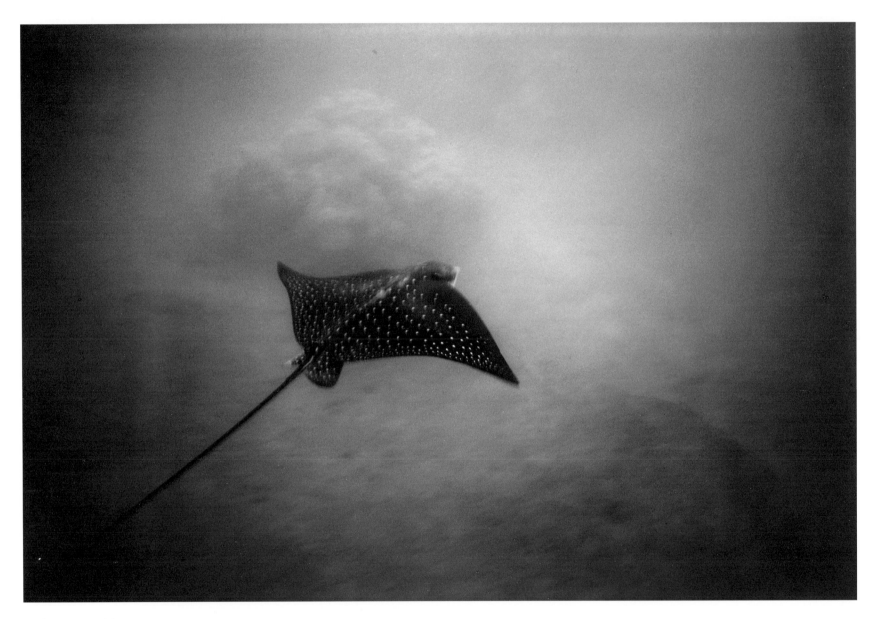

46

eagle ray, Hawai'i

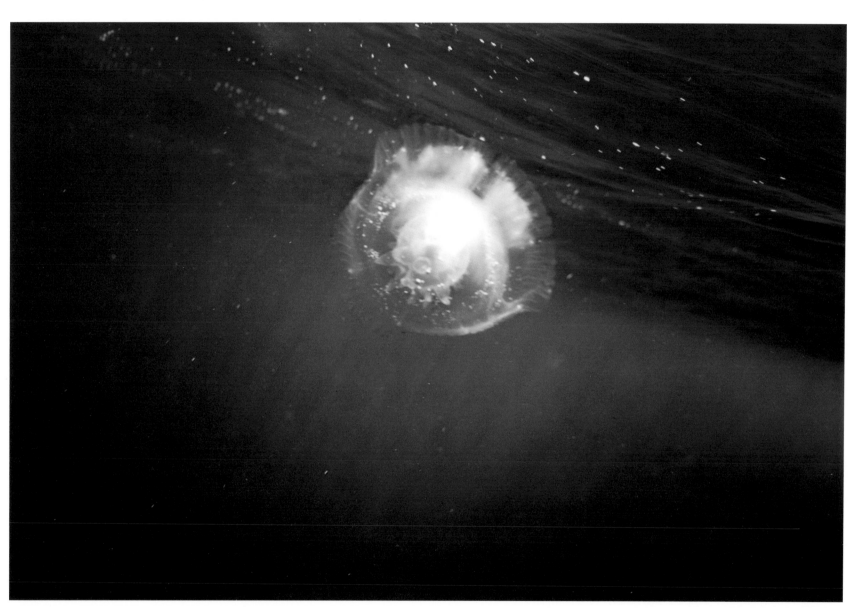

47

jellyfish, Hawai'i

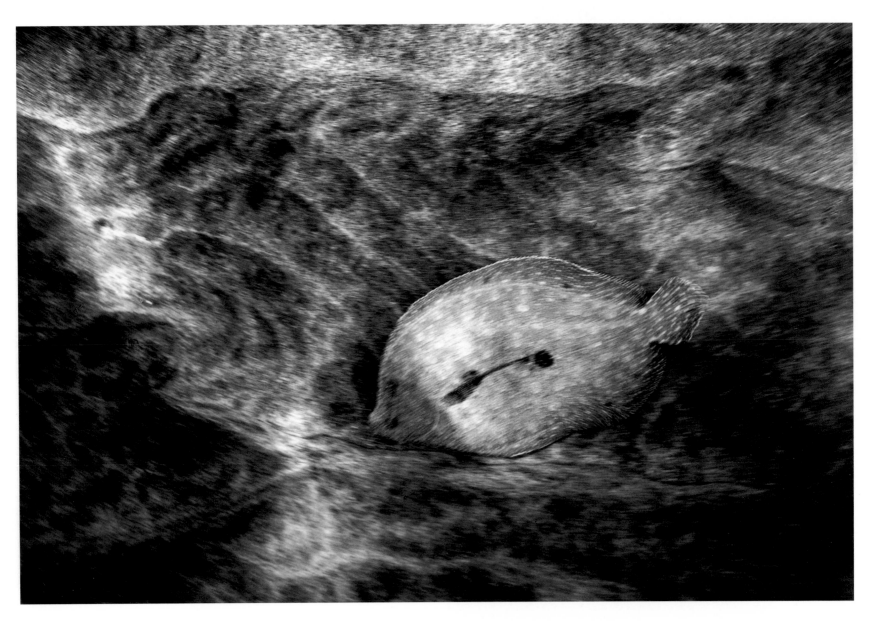

peacock flounder, Hawai'i

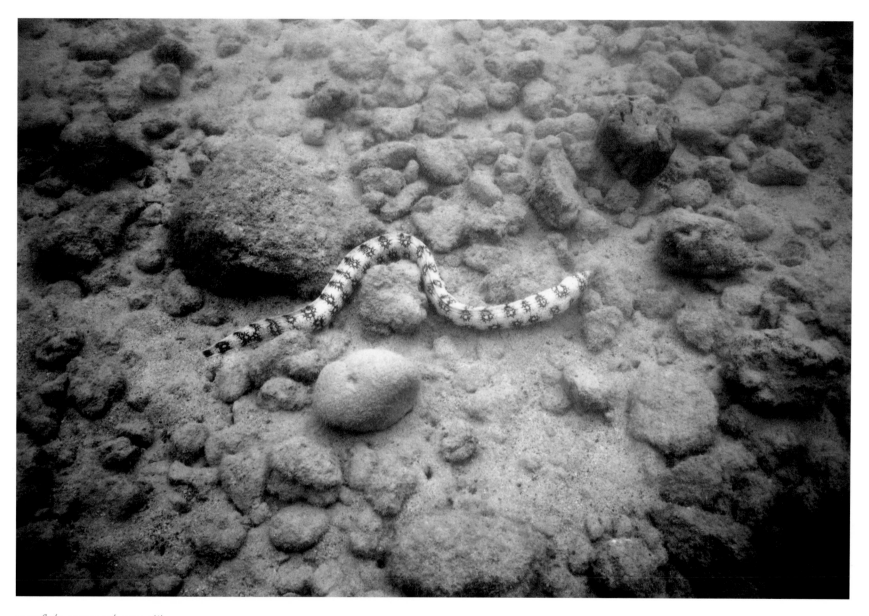

49

snowflake moray eel, Hawai'i

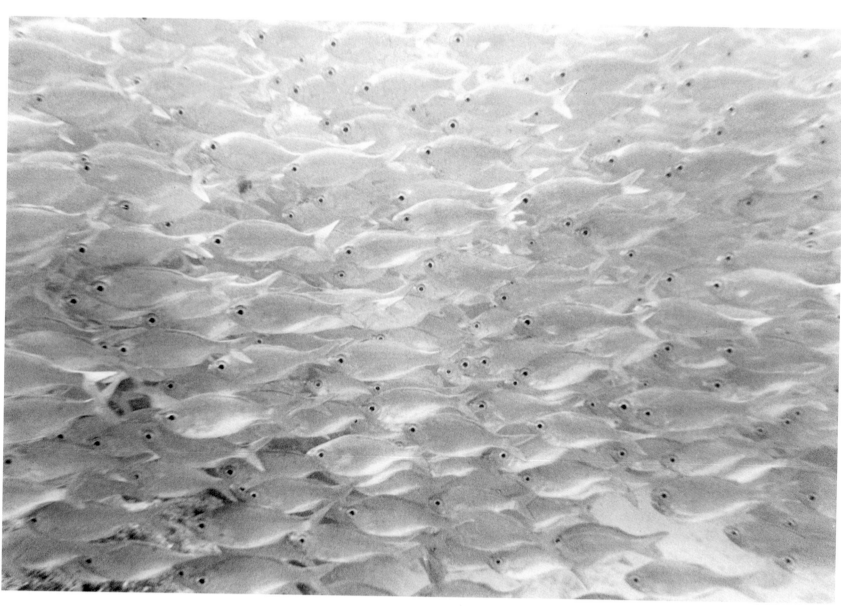

silver perch, O'ahu

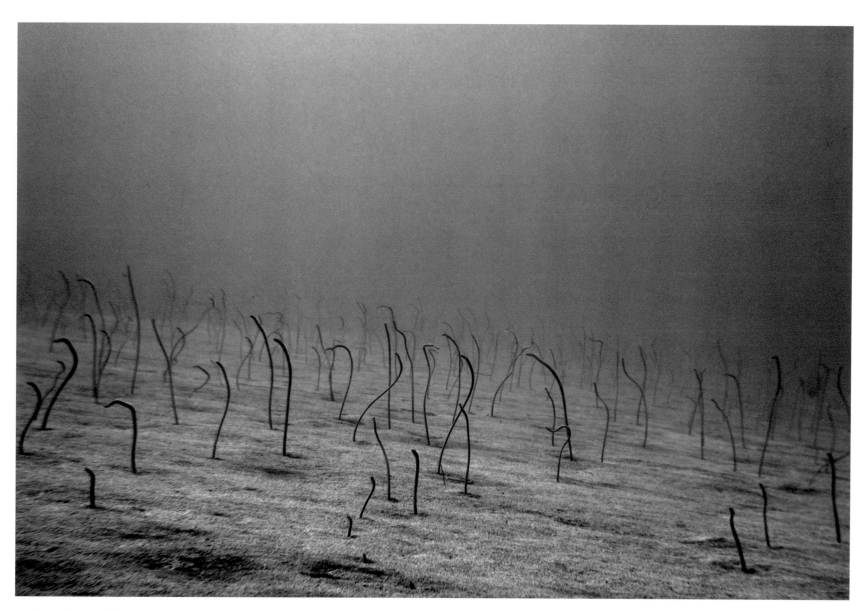

garden eels, Hawai'i

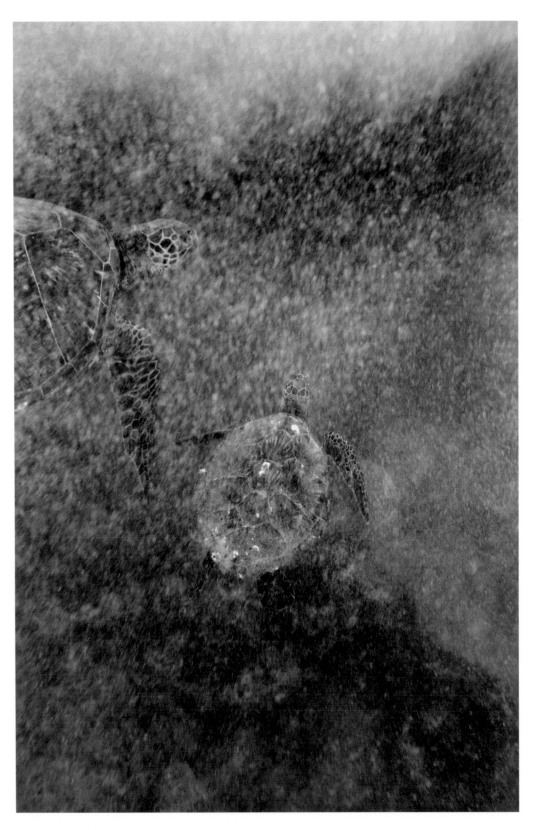

green sea turtles, O'ahu

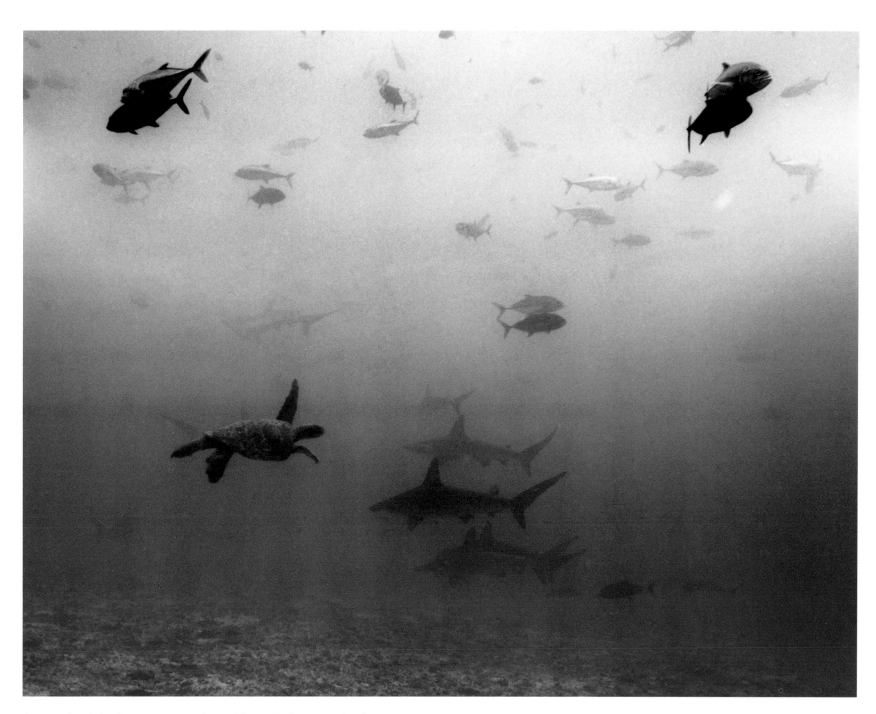

hammerhead sharks, green sea turtle, and bigeye jacks, Cocos Island

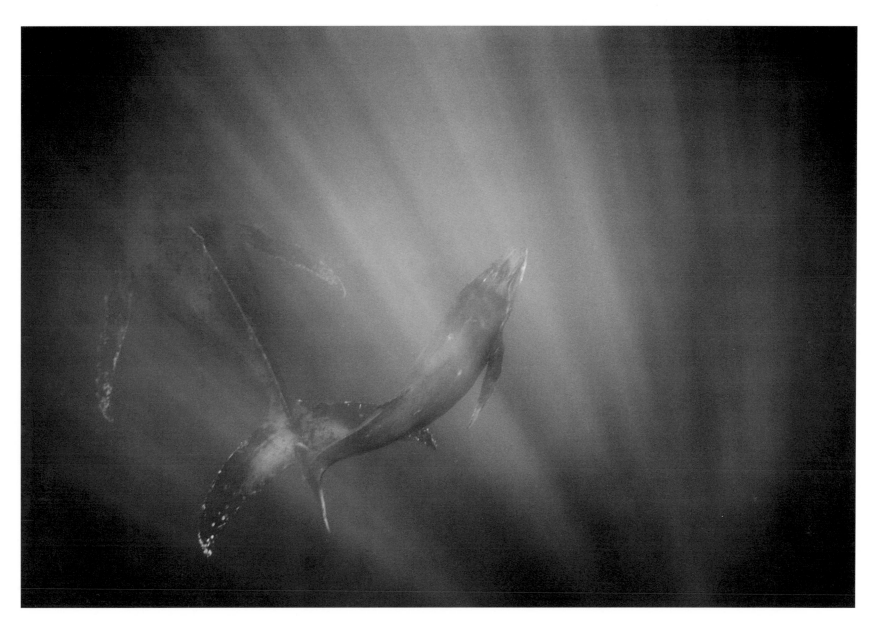

baby and mother humpback whales, Hawai'i

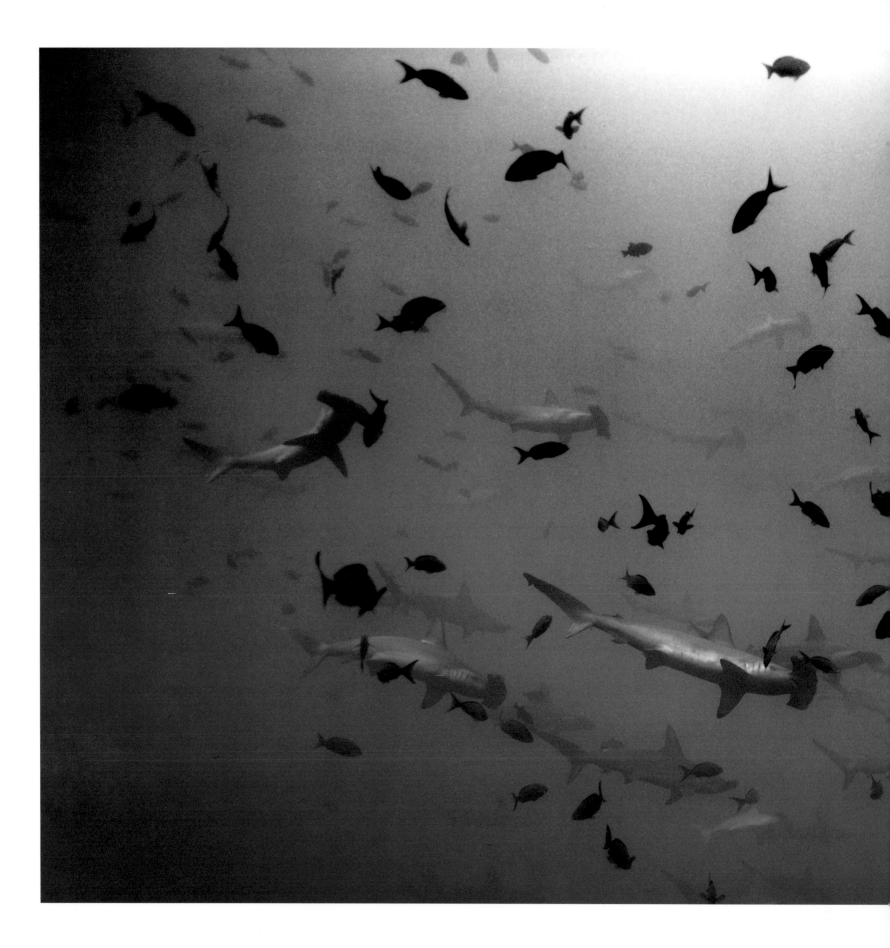

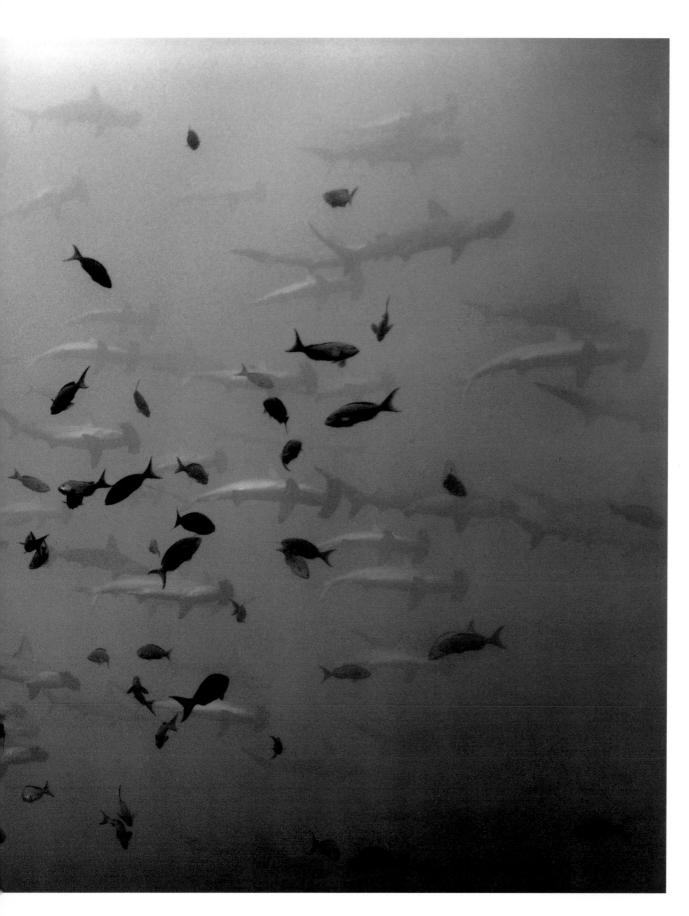

school of scalloped hammerhead sharks 57
and reef fish, Cocos Island

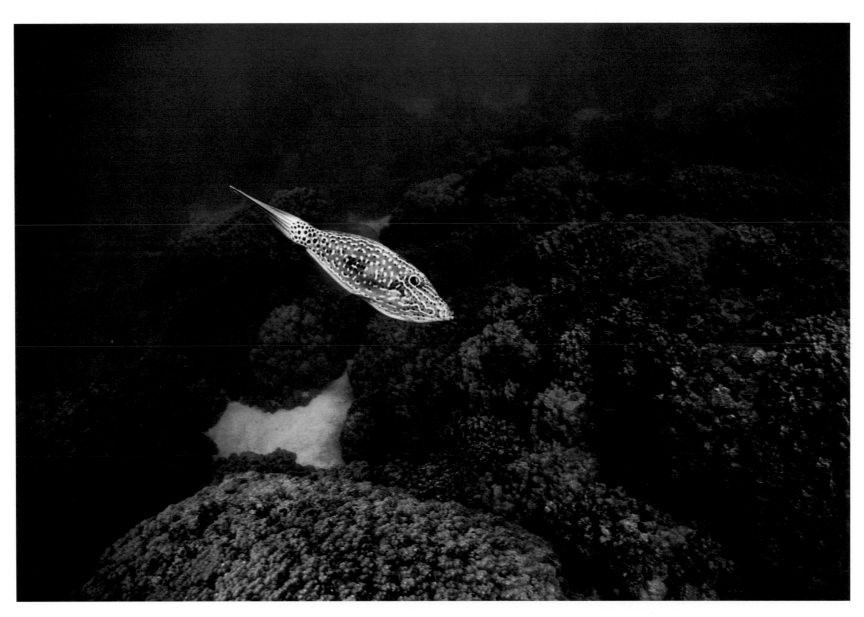

filefish, Hawai'i

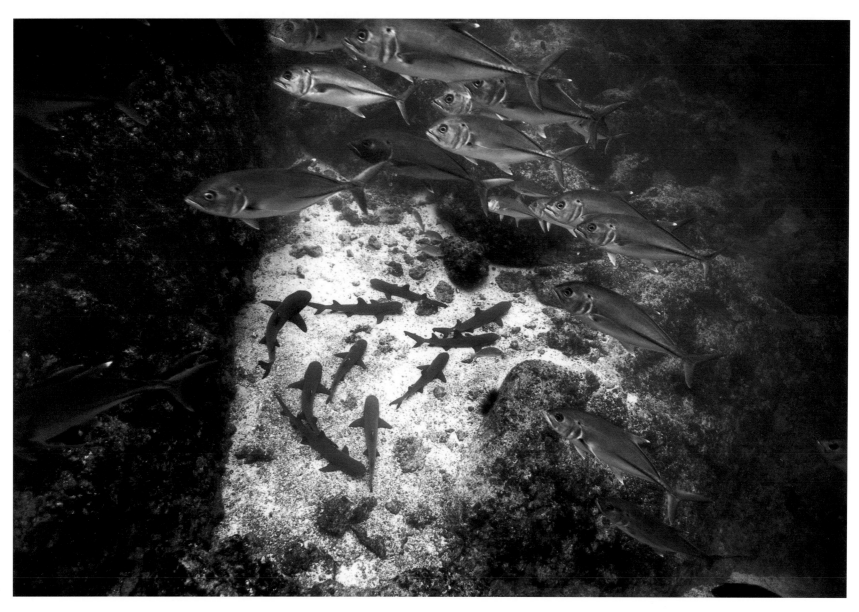

bigeye jacks and whitetip reef sharks, Cocos Island

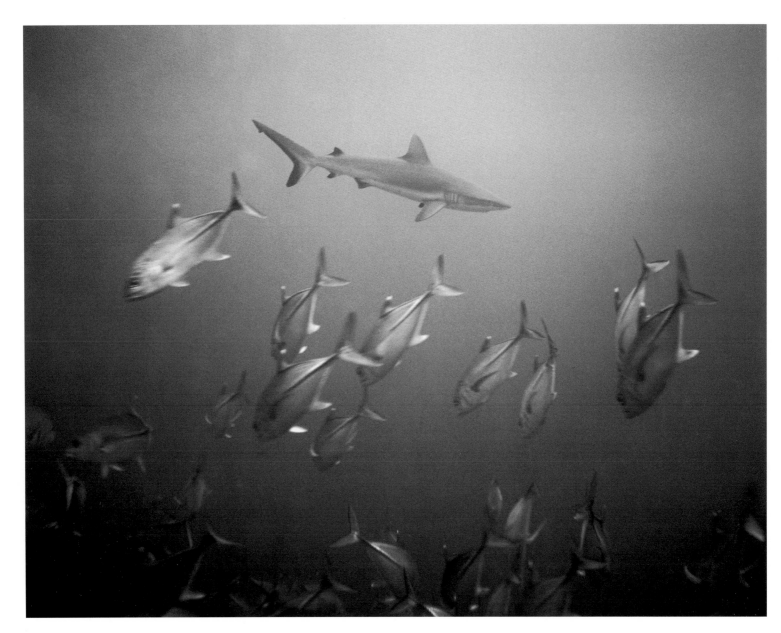

bigeye jacks and gray reef shark, Bikini Atoll

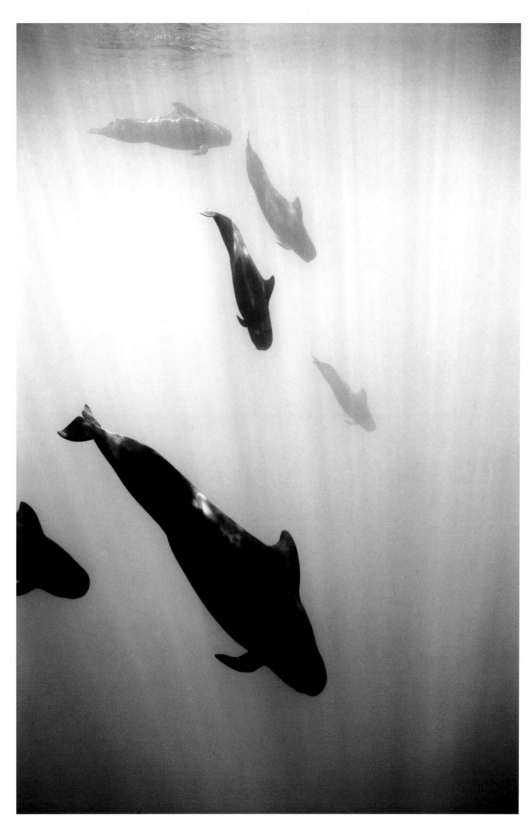

pilot whales, Hawai'i

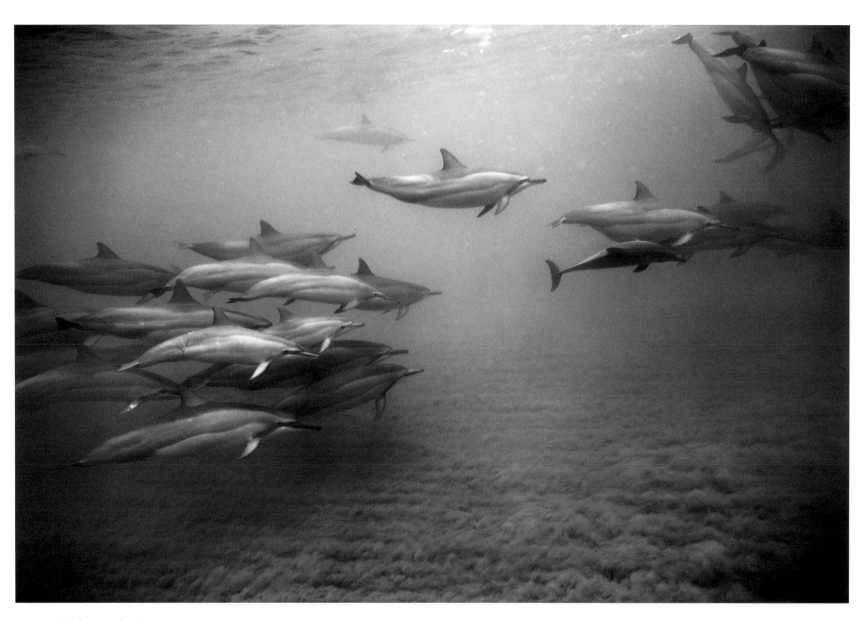

62

spinner dolphins, Kahoʻolawe

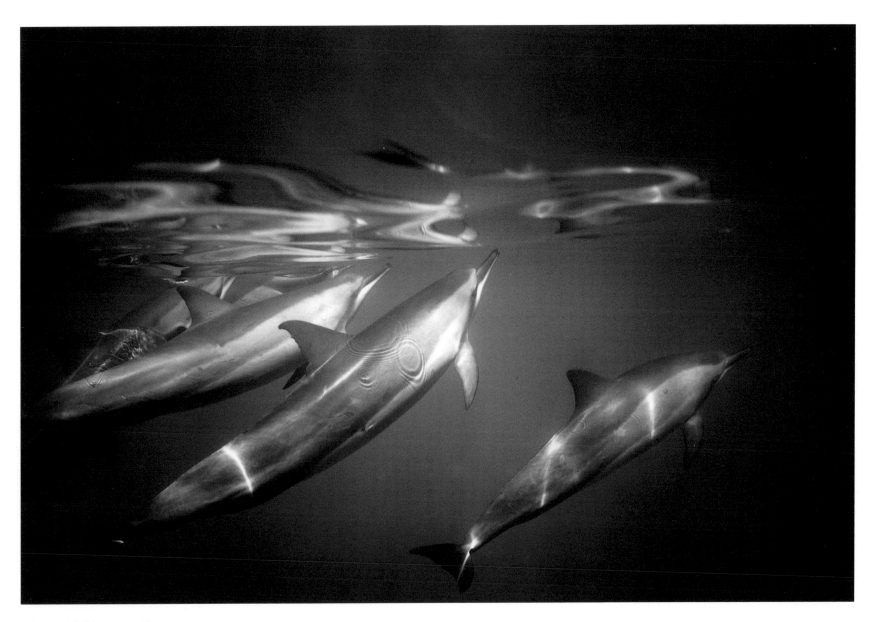

63

spinner dolphins, Hawai'i

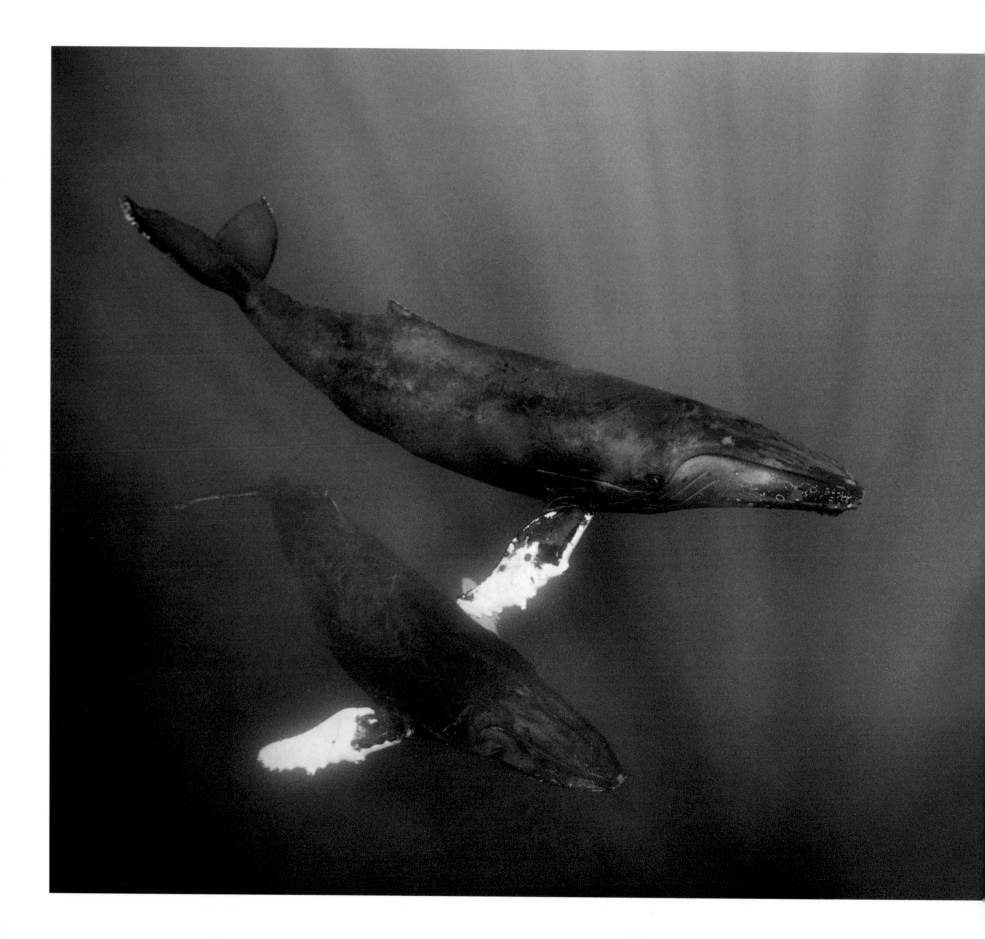

humpback whales, Hawai'i

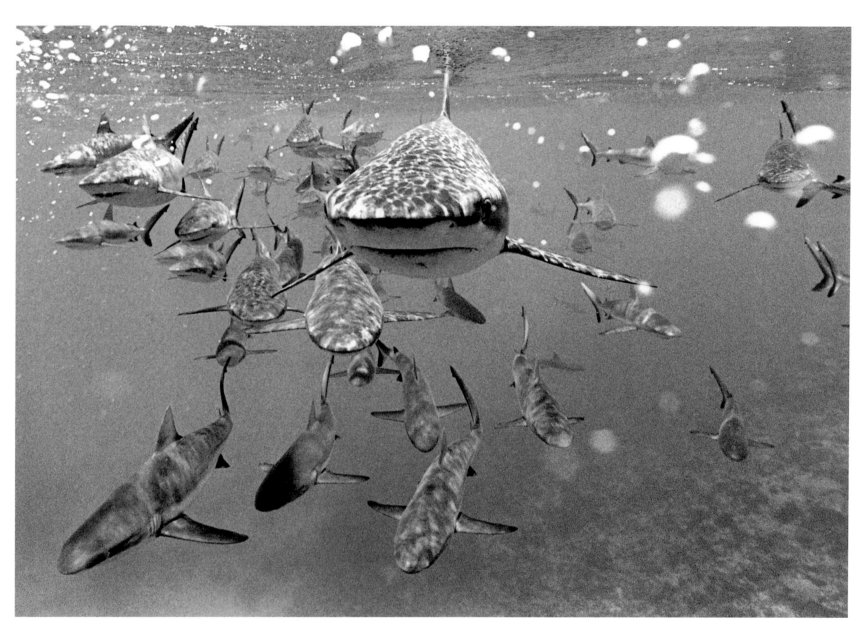

gray reef sharks, Bikini Atoll

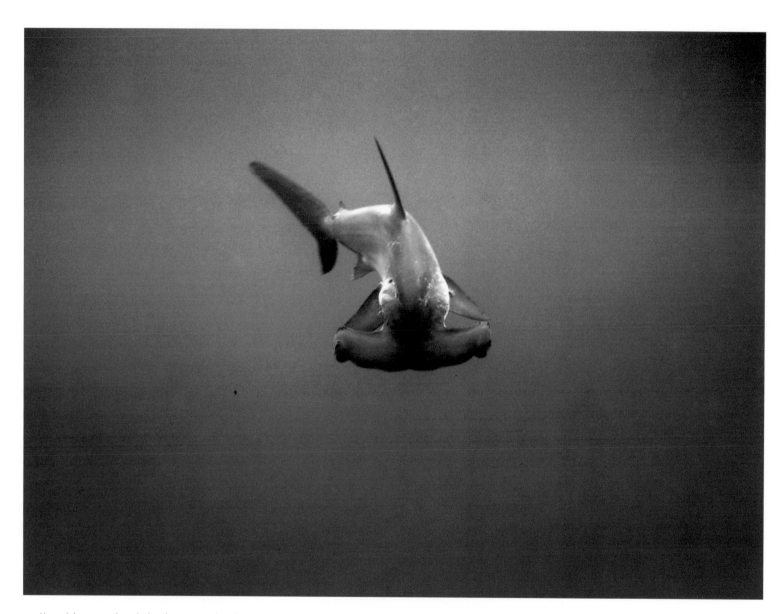

scalloped hammerhead shark, Cocos Island

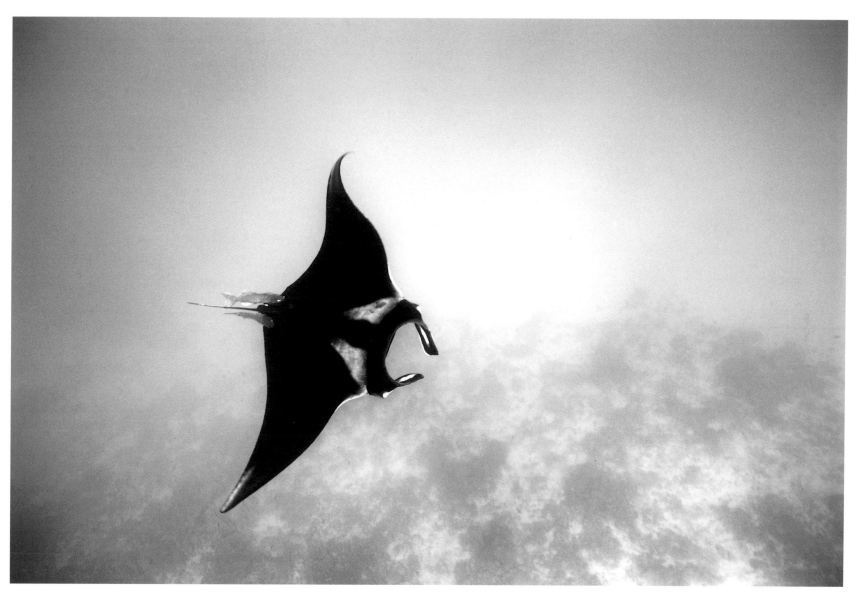

manta ray with remoras, Hawai'i

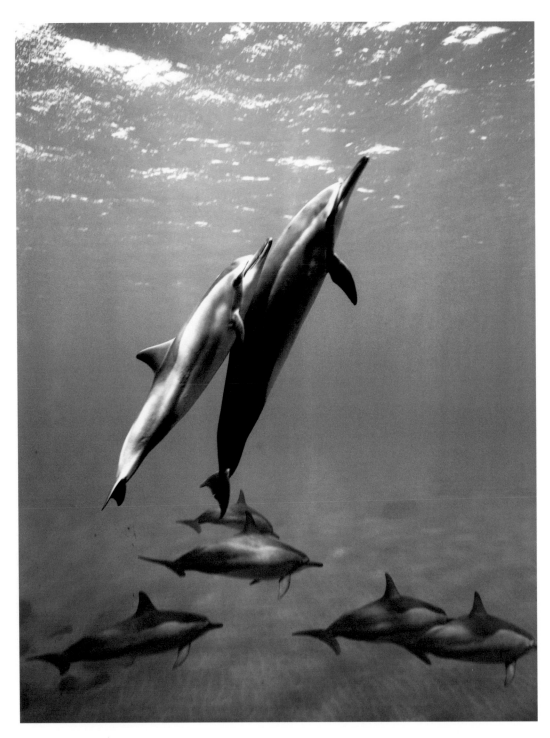

spinner dolphins, Kaho'olawe

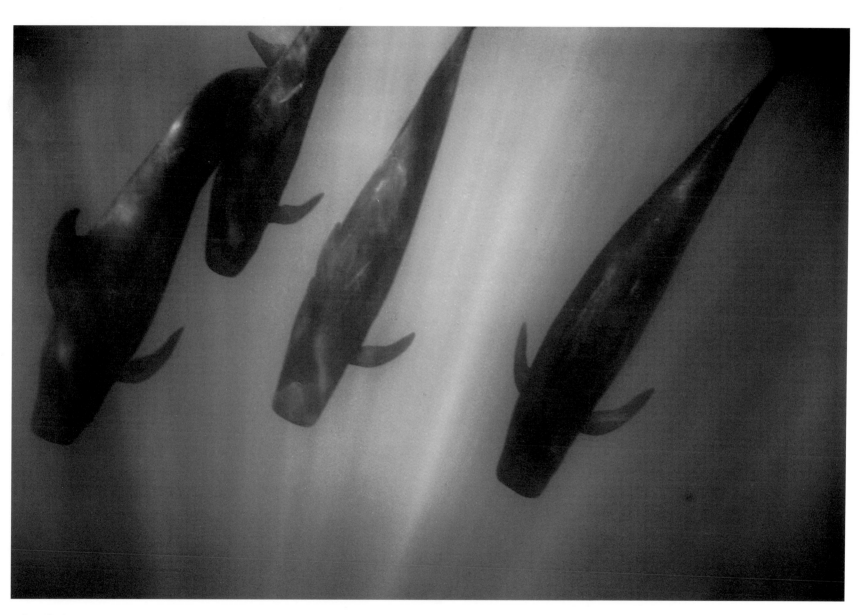

pilot whales, Hawai'i

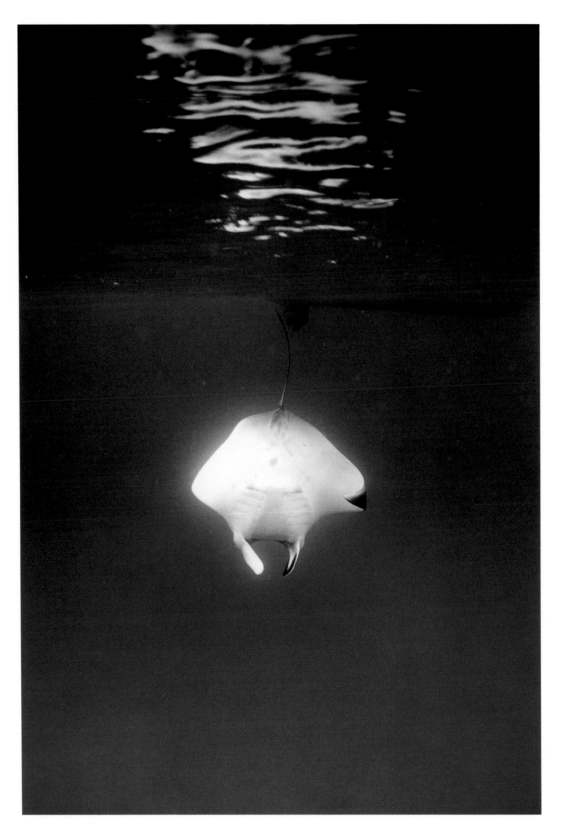

manta ray, Cocos Island

riley

relics

Full fathom five thy father lies,
Of his bones are coral made:
Those are pearls that were his eyes:
Nothing of him that doth fade,
But doth suffer a sea-change
Into something rich and strange.
Sea-nymphs hourly ring his knell:
Ding-dong.
Hark now I hear them — ding-dong bell.

——— *Shakespeare « The Tempest »* ———

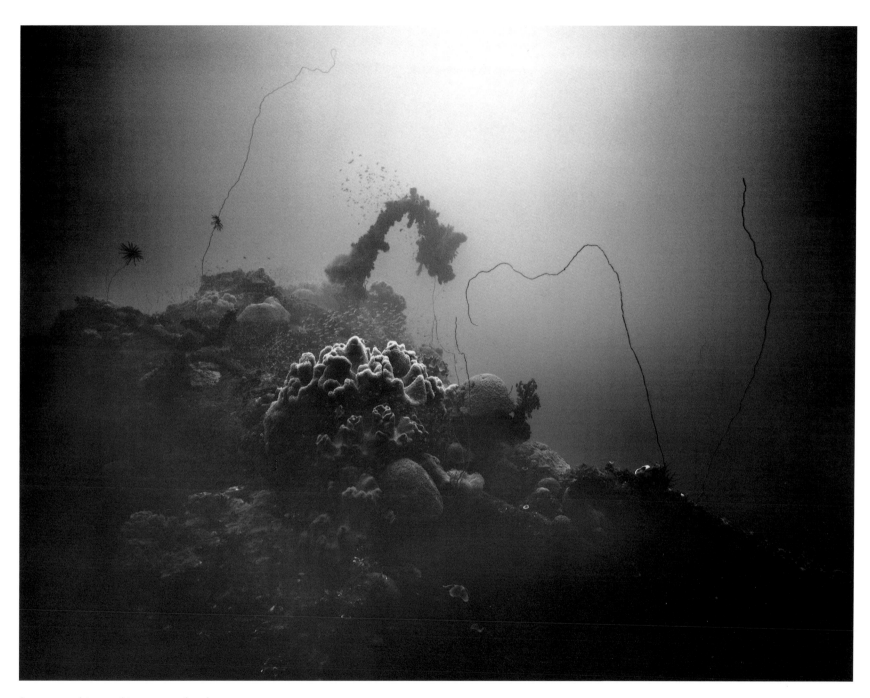

bow, cargo ship « Hoki Maru, » Chuuk Lagoon

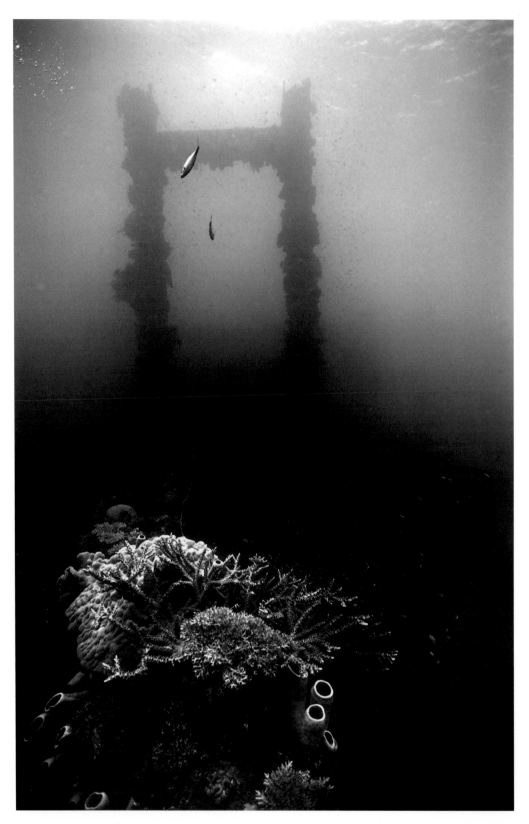

deck and derrick, cargo ship « Fujikawa Maru, » Chuuk Lagoon

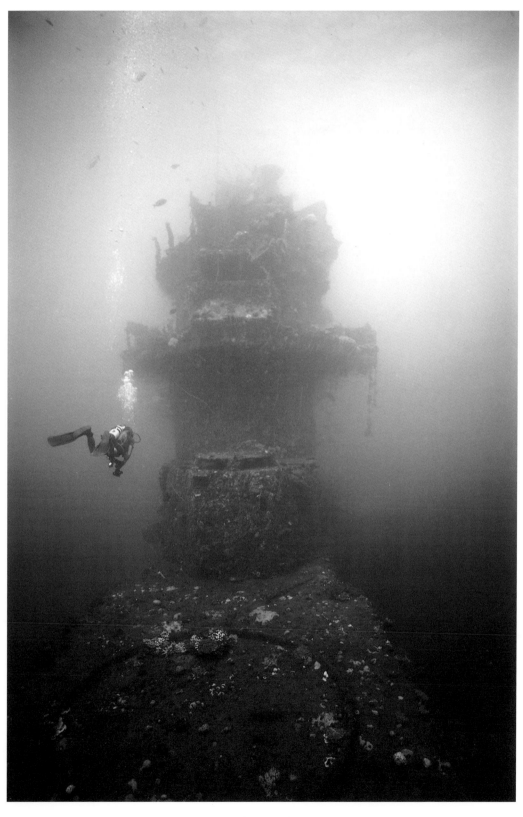

superstructure, aircraft carrier «Saratoga,» Bikini Atoll

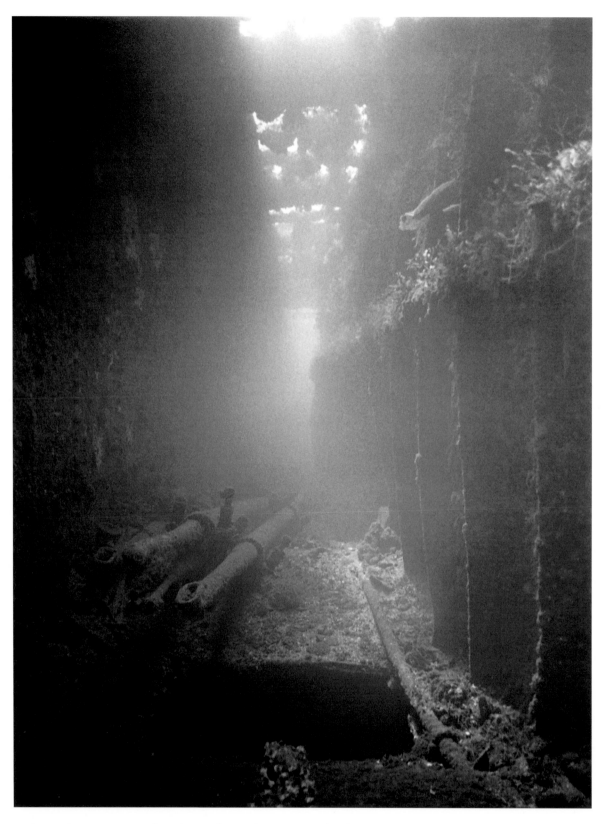

periscopes in passageway, submarine tender « Heian Maru, » Chuuk Lagoon

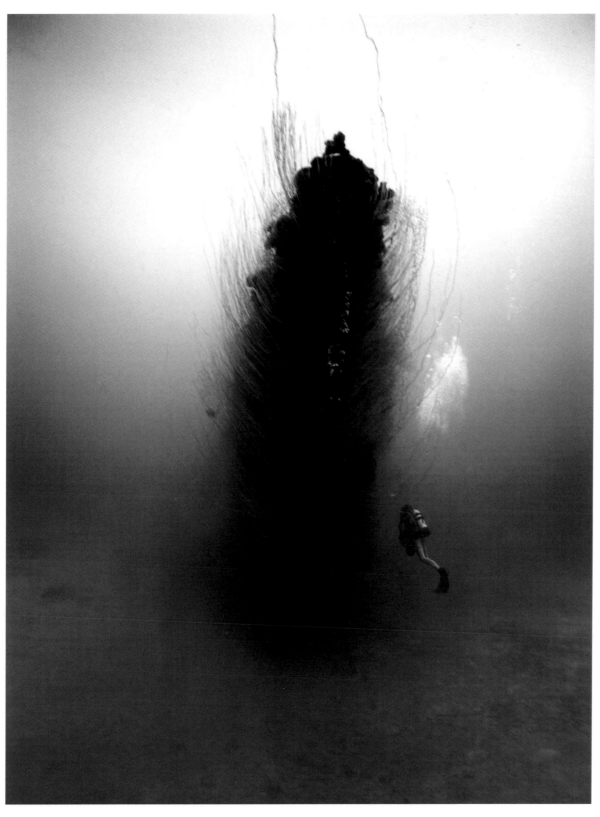

bow, submarine « Apogon, » Bikini Atoll

Eighteen-inch guns, battleship « Nagato, » Bikini Atoll

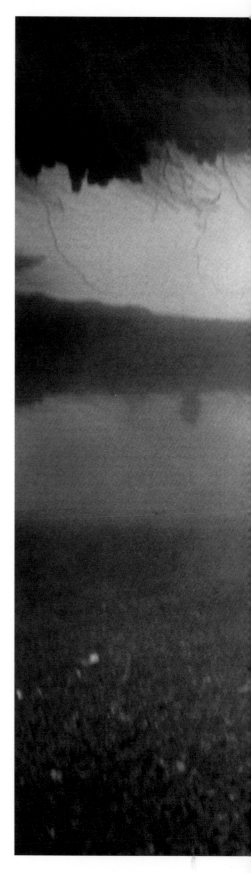

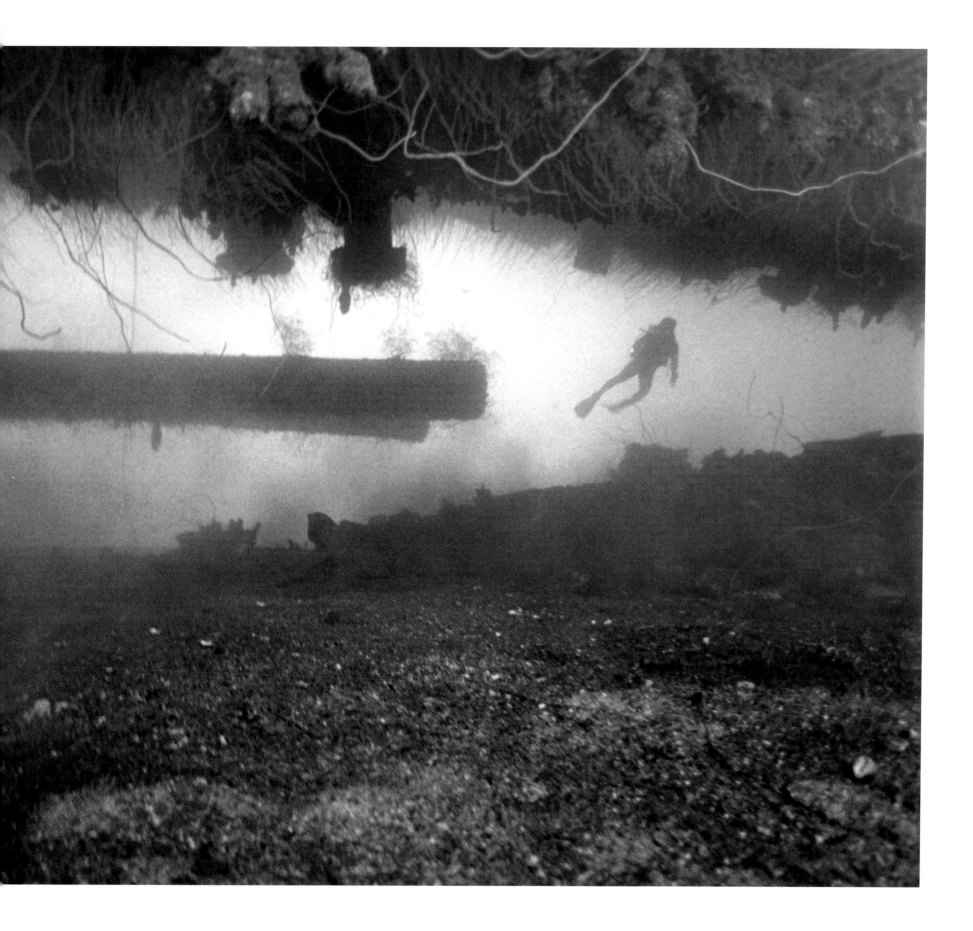

mast, « Fujikawa Maru, » Chuuk Lagoon

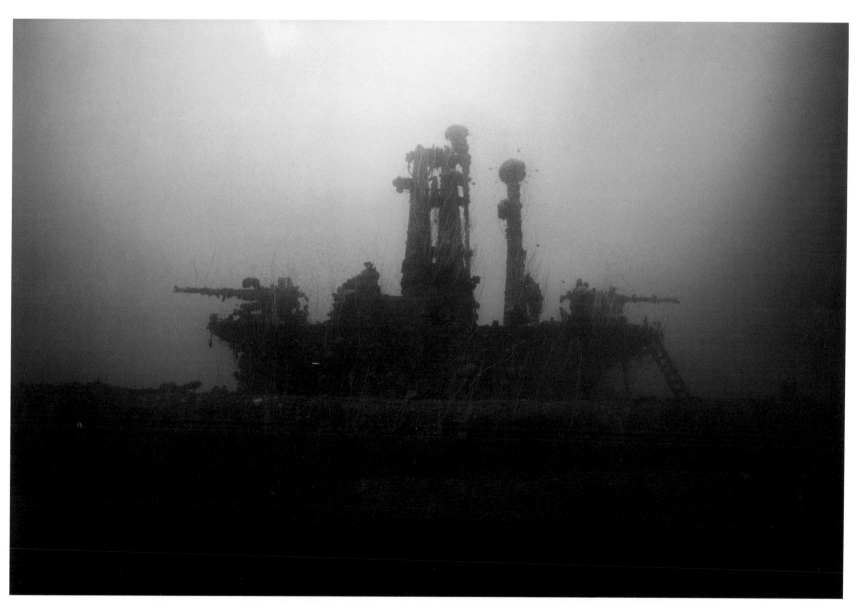

conning tower and guns, « Apogon, » Bikini Atoll

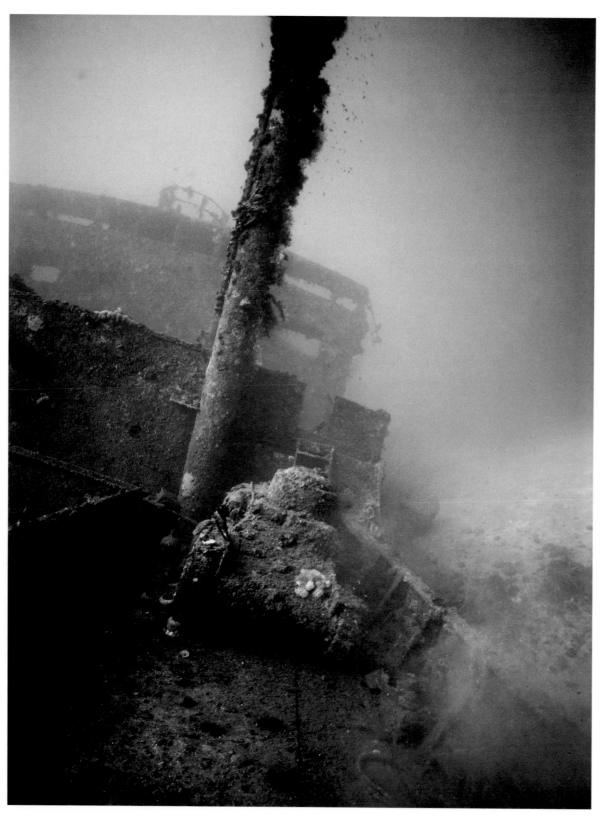

tank on deck, cargo ship « Nippo Maru, » Chuuk Lagoon

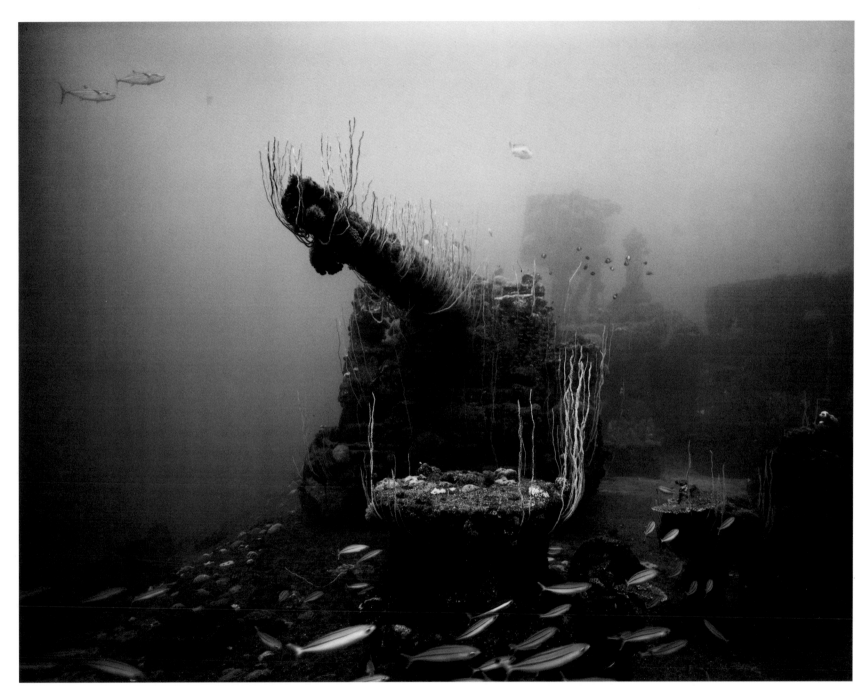

bow gun, transport ship « Gilliam, » Bikini Atoll

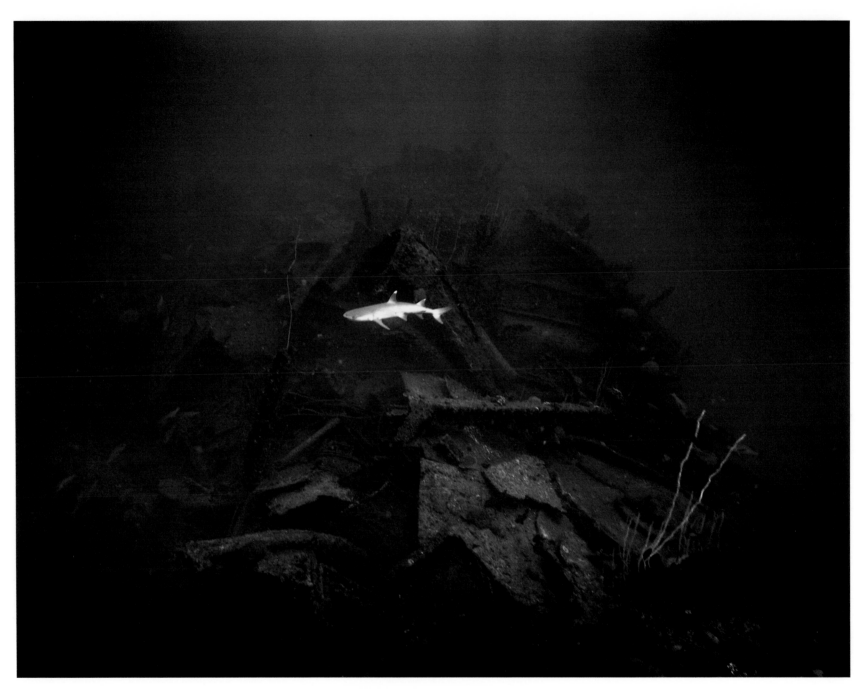

86

whitetip reef shark, deck of the « Gilliam, » Bikini Atoll

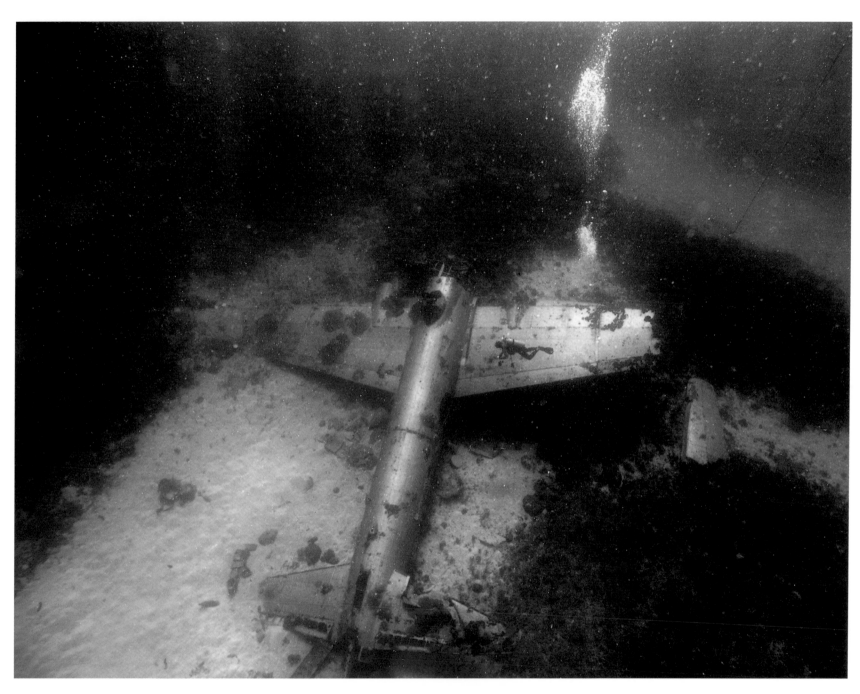

Japanese « Betty » bomber, Chuuk Lagoon

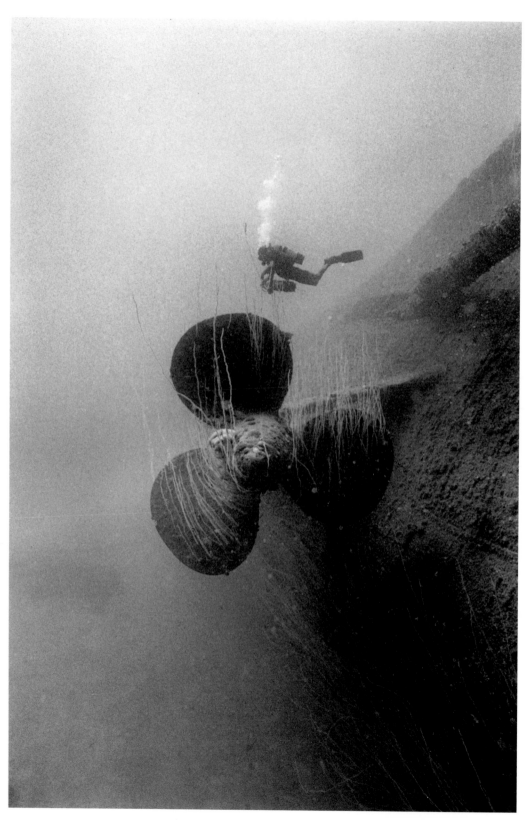

propeller, « Nagato, » Bikini Atoll

what our world between betrayed

between two worlds

« Oh, Kitty, how nice it would be if we could only
get through into Looking-glass House.
I'm sure it's got, oh! such beautiful things in it! . . .
Let's pretend the glass has got soft like gauze. . . .
Why, it's turning into a sort of mist now, I declare.
It'll be easy enough to get through — »

Lewis Carroll

« Through the Looking-Glass »

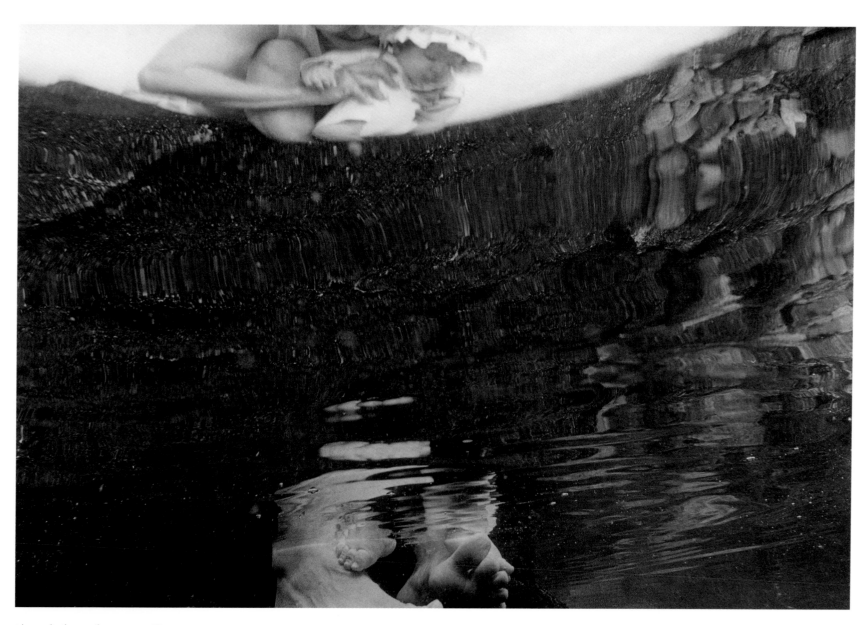

through the surface, Hawai'i

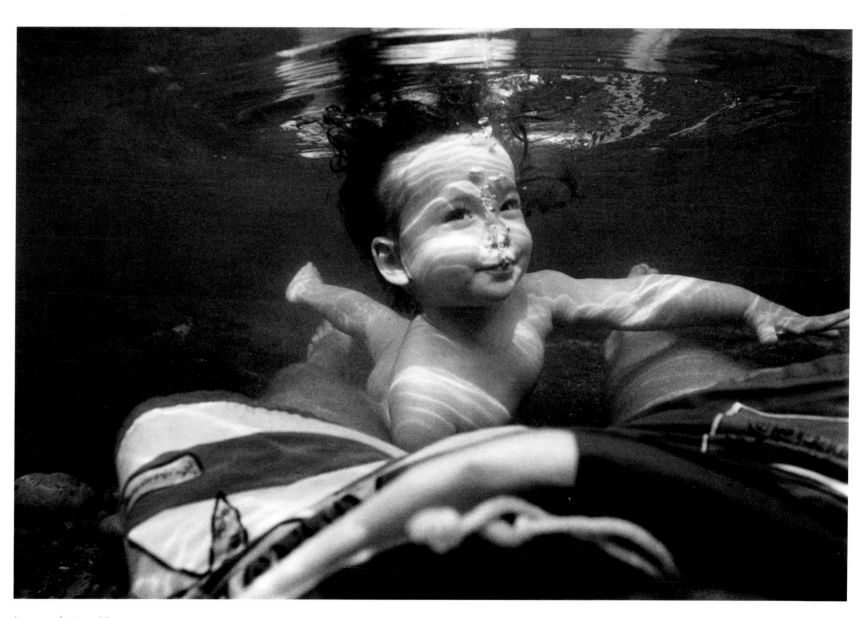

immersed, Hawai'i

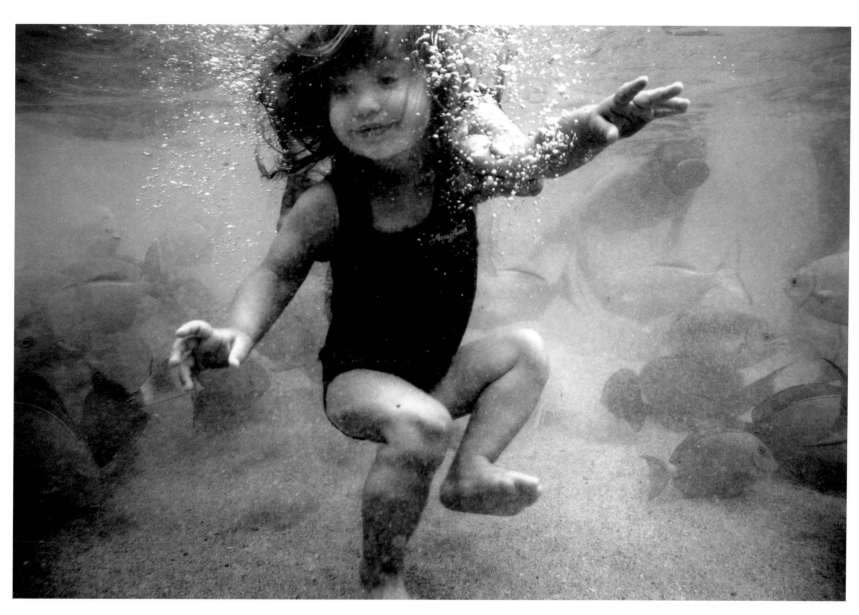

dancing with fish, O'ahu

Note on Introduction Aspects of this essay draw on material initially explored, in different form, in *On Water* (The Ecco Press, 1994) and, with photographs by Wayne Levin, in articles for *Ocean Realm Magazine* (Autumn 1996) and *Longboard Magazine* (April 1997).

Photographer's Notes All the surfer, whale, and dolphin photographs were taken while free diving—with mask and fins—generally after long kayak paddles and/or swims and after much waiting on the open ocean. Most of the wreck and shark photographs were shot while using scuba equipment—air tanks and regulator allowing deeper diving, in some cases below 150 feet. The cameras for all photographs were Nikonos IV and Nikonos V, with Nikonos lenses (35, 28, 20, and 15 millimeter).

page 2
Diving humpback whale. Humpbacks migrate from Alaska to the Hawaiian Islands where they spend the winter months. Note second whale in upper left background. Kona coast, Hawai'i, 1997.

page 5
Bodysurfer diving beneath incoming wave. The cloudlike effect is caused by the heavy aeration of water when a wave breaks. Thus, underwater clouds are air in water. (Conversely, clouds in the sky are water droplets in air.) Makapu'u, O'ahu, 1983.

page 6
Wave breaking on reef, Hōnaunau, Hawai'i, 1990.

Wave Riders

page 19

Three bodysurfers dive under a large breaking wave. Two of the surfers have hand boards used for greater control when riding the face of a wave. In heavy surf of this kind, I use only goggles and fins, with my Nikonos strapped to my wrist. Here, I dove under the outside waves with the surfers and took this photograph while suspended in the comparative calm beneath the turbulence. Makapu'u, O'ahu, 1983.

page 20

"Pearling." This surfer has just taken off on a wave and dug the nose of his surfboard into the water in a "pearl dive," which marks the end of his short ride. Full Point, Sandy Beach, O'ahu, 1983.

page 21

Underwater takeoff. In an extraordinary maneuver, lifeguard and champion bodysurfer Mark Cunningham is about to break the surface and catch a wave, the curve of which can be seen in the upper left. The wave has kicked up the sandy bottom as seaweed floats in the liquid space. Mark and I have been collaborating on a series of such images. Makapu'u, O'ahu 1996.

pages 22 and 23

Mark Cunningham is in the process of "kicking out" of a wave as it breaks on the beach. The shore break at Sandy Beach is notorious for steep waves that break on a shallow bottom with the risk of serious injury to surfers. Sandy Beach, O'ahu, 1996.

page 24

When the seaweed comes in, the consistency of the water changes as well as its smell and taste. Makapu'u, O'ahu, 1983.

page 25

I'm facing the "lip" of the wave as a bodysurfer is seen going out through the wave. This photograph is taken from above the surface but in the water. Sandy Beach shore break, O'ahu, 1983.

page 26

"Taking off." This photograph, and the one preceding, are the only photographs in the book taken from above the surface. In both cases, it was necessary, immediately after shooting, to dive underwater for protection from the advancing wave. Makapu'u, O'ahu, 1984.

page 27

"Over the falls." The bodysurfer is being pulled over the lip and down the face of a breaking wave. Taken from behind the wave, this photograph shows his head and arm submerged. Sandy Beach shore break, O'ahu, 1983.

page 29

Floating. Note the leg of a second surfer in the lower right corner. The darker cloudlike forms are where the large wave is breaking. The lighter cloud forms are the foamy whitewater occurring after the break. Makapu'u, O'ahu, 1983.

page 30

Surfer diving under a wave. Such traditional boards, made of wood, are not seen often these days. East Shore, O'ahu, 1992.

page 31
Mark Cunningham is riding underwater the way seals and dolphins surf, being pulled by the pressure of the wave. No mean feat! Half Point, Sandy Beach, Oʻahu, 1995.

page 32
Holding breath. The leg of a second bodysurfer swimming through the wave can be seen at the top of frame. Makapuʻu, Oʻahu, 1984.

page 33
An exhaling bodysurfer is about to surface, with Mark Cunningham in the background. Sandy Beach shore break, Oʻahu, 1995.

page 34
Surfer surfacing behind wave. The texture behind the surfer is the face of the passing wave. Full Point, Sandy Beach, Oʻahu, 1983

page 35
Suspended. The sand is kicked up by breaking waves. Sandy Beach shore break, Oʻahu, 1984.

page 36
Viewing fish. The Bay is a snorkeling heaven. Though here we sense a human awkwardness—humans out of their element, as opposed to the surfers—there is still for me a real beauty in seeing the interaction of fish and people. Hanauma Bay, Oʻahu, 1987.

Resident Spirits

page 39
Bigeye jacks, whitetip reef shark, and puffer fish. Cocos is about three hundred miles off the Pacific shore, a remote lush island, uninhabited except for rangers, now a national park. Because of restrictions on fishing, there is abundant marine life, including an extensive shark population. Depth at the bottom here is about one hundred feet. Cocos Island, 1995.

page 40
These spinner dolphins often go into the shelter of the bay to rest during daylight, heading out to deep water at night to feed. Kealakekua Bay, Hawaiʻi, 1990.

page 41
Bonefish, about two feet long, at Kealakekua Bay, Hawaiʻi, 1991.

page 42
The green sea turtle's fin motion is kicking up a cloud of fine sand on the bottom. Kealakekua Bay, Hawaiʻi, 1990.

page 43
Humpback whale. I was out kayaking near the northern tip of the island. The whale's heavy discoloration may indicate that it is old. The whale also made a whistling or wheezing sound when it blew. As noted above, all the whale and dolphin photographs as well as most of the turtle photographs were taken free diving—with mask, snorkel, fins, and a lungful of air. Kohala coast, Hawaiʻi, 1990.

page 45
Pilot whales are some fifteen to eighteen feet long and patrol this coast year-round. Three to five miles offshore in very deep water, South Kona coast, Hawai'i, 1991.

page 46
These beautiful spotted eagle rays have poisonous barbs on their long tails and can inflict a very painful sting. Kohala coast, Hawai'i, 1990.

page 47
Jellyfish floating just off the rocky shore. Hōnaunau, Hawai'i, 1991.

page 48
The peacock flounder is camouflaged in the sandy bottom. Kealakekua Bay, Hawai'i, 1991.

page 49
The snowflake moray eel undulates its way through the rocks along a shallow sandy beach. Kohala coast, Hawai'i, 1996.

page 50
Silver perch. This huge school was a wall of fish, forming a tunnel I could swim through. Hanauma Bay, O'ahu, 1987.

page 51
These garden eels are plentiful here, anchoring their tails in the sand in deep water—at about one hundred feet— and feeding on plankton. Their undulations in the current made them seem like dancing cobras responding to some aquatic melody. South Kona, Hawai'i, 1996.

page 52
Green sea turtles. Adult and baby are swimming at Blowhole Beach (Hālona) in very turbulent water. East shore, O'ahu, 1992.

page 53
Hammerhead sharks, green sea turtle, and bigeye jacks. The profusion of marine life here was amazing, often more than the eye could make sense of. Cocos Island, 1995.

page 55
Baby and mother humpback whales. The baby is turning around just after having swum down the length of its mother's back. South Kona coast, Hawai'i, 1990.

page 56 and 57
School of scalloped hammerhead sharks and reef fish. Sightings of such schools are becoming less frequent because of the destruction of the species worldwide due to the finning of sharks by humans—for soup. Cocos Island, 1995.

page 58
Filefish swimming above the rich reef. Hōnaunau, Hawai'i, 1997.

page 59
Bigeye jacks and whitetip reef sharks. The sharks are resting or "asleep" at a depth of about one hundred feet. Cocos Island, 1995.

page 60
Bigeye jacks and gray reef shark above the wreck of the *Gilliam* at a depth of 135 feet. Bikini Atoll, 1996.

page 61
Pilot whales. Such photographs were achieved by making one long free dive as the whales approached our boat. South Kona coast, Hawai'i, 1991.

page 62
Spinner dolphins. It's a rainy day and wave action is kicking up the sand on the bottom. Hanakanai'a, Kaho'olawe, 1994.

page 63
Spinner dolphins. Concentric circles from the dolphins' splashes on the surface projected onto their bodies. Kealakekua Bay, Hawai'i, 1991.

page 64 and 65
Humpback whales passing near Keauhou, Hawai'i, 1997.

page 67
Gray reef sharks. This huge school was off the outer reef. I was not in the water; I made the photograph by dipping my camera in the ocean from the transom of the dive boat. This was still unsettling, since the sharks apparently considered my camera a kind of food and rushed it repeatedly. Bikini Atoll, 1996.

page 68
Scalloped hammerhead shark approaching me. Cocos Island, 1995.

page 69
The manta ray is some ten feet across, and is carrying two remoras. North Kona coast, Hawai'i, 1996.

page 70
An adult spinner dolphin with a juvenile approaching the surface. Hanakanai'a, Kaho'olawe, 1994.

page 71
Pilot whales just beginning their dive. South Kona coast, Hawai'i, 1991.

page 72
The manta ray's white underside faces the camera with a dive boat in the background. Cocos Island, 1995.

Relics
In 1944, American planes attacked the Japanese naval base at Chuuk Lagoon. In a series of attacks, the Americans sank over sixty Japanese ships. In the fifty years since the attack, entire reef systems have evolved on the sides of these ships. These photographs at Chuuk Lagoon were taken in 1995.

In 1946, the U.S. government began a series of nuclear tests on Bikini Atoll known as "Operation Crossroads." Nearly one hundred ships were used as targets, many of which were sunk. Today, a few of these ships have been located, and though quite deep, can be explored with scuba equipment. These photographs at Bikini Atoll were taken in 1996.

page 75
The *Hoki Maru* is so thick with coral encrustation that only the stanchion on the tip of the bow seems man-made. Chuuk Lagoon.

page 77
The *Saratoga* was "unsinkable," having survived many major World War II battles, but was sent to the bottom in atomic testing. Bikini Atoll.

page 78
The *Heian Maru* is lying on its side. Chuuk Lagoon.

page 79
A diver is inspecting the bow in 170 feet of water. Bikini Atoll.

page 80 and 81
The *Nagato* is upside down in 165 feet of water. It was Supreme Commander Admiral Yamamoto's flagship and the only Japanese battleship to survive World War II. Bikini Atoll.

page 82
The mast of the wreck of the cargo ship *Fujikawa Maru*. Chuuk Lagoon.

page 84
The *Nippo Maru's* bridge and part of the cargo derrick can be seen in the background. Chuuk Lagoon.

page 87
A Japanese "Betty" bomber, in fifty feet of water. Note diver over left wing. Chuuk Lagoon.

page 88
One of four huge propellers or screws. The diver carries an extra air tank for safety because of the very deep diving. Bikini Atoll.

Epilogue — Between Two Worlds

page 91
My daughter Elise at about six months with her mother, Mary Belanger, at a tidepool. Their feet are in the water, and the bottom of the tidepool is reflected on the under-surface of the water. At a particular angle one is able to see through the surface from below. Hōnaunau, Hawaiʻi, 1991.

page 93
Elise, age two, happily immersed in a tidepool. My legs can be seen extending into the background of the frame. Hōnaunau, Hawaiʻi, 1993.

page 95
Elise, age three, dancing with fish, Hanauma Bay, Oʻahu, 1994.

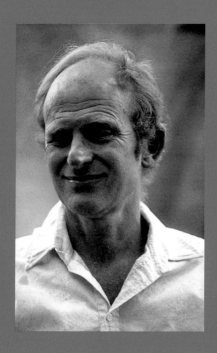

Acknowledgments

So many people helped: Robert Adams, Chris Burt, Linda Connor, Mark Cunningham, Gavan Daws, Aaron Dygart, Lynn Davis, Charlene deJori, Kit Duane, Jaimey Easler, Jay Jensen, Fran Kaufman, Diana Landau, Elaine Mayes, Barbara Pope, David Rick, Stephen Rosenberg, Curt Sanburn, and Gaylord Wilcox. Special thanks to Tom Farber, for his unwavering advocacy of my work. Finally, I've been sustained on land and water by my parents, Mel and Clare, and by my wife, Mary Belanger, and our daughter Elise—partners on the voyage. W. L.

Wayne Levin

Wayne Levin's photographs have appeared in magazines such as *Aperture, Ocean Realm, American Photographer, Pacifica,* and *Hemispheres.* His books include *Kalaupapa: A Portrait,* and *Preservations,* and he was one of the principal photographers for *Kahoʻolawe: Nā Leo o Kanaloa.* A National Endowment for the Arts Fellow, Wayne Levin has photographs in collections including the Museum of Modern Art, New York City; Bishop Museum, Honolulu; and the Hawaiʻi State Foundation on Culture and the Arts.

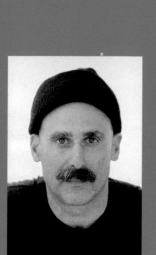

Thomas Farber

Awarded Guggenheim, National Endowment, and Rockefeller fellowships for his fiction and creative nonfiction, author of books including *The Price of the Ride, On Water,* and *Learning to Love It,* Thomas Farber has been Distinguished Visiting Writer at the University of Hawaiʻi, Fulbright Scholar for Pacific Island Studies, and recipient of the Dorothea Lange–Paul Taylor Prize.